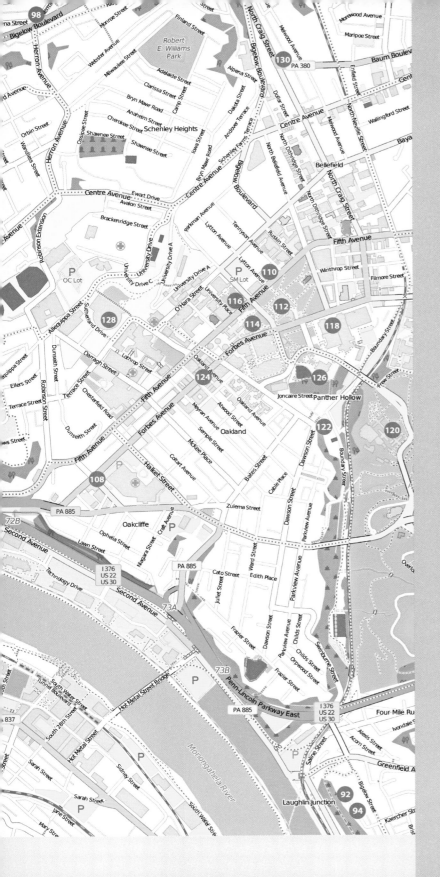

PITTSBURGH THEN AND NOW

You can find most of the sites featured in the book on this outline map*

Numbers in red circles refer to the pages where sites appear in the book.

* The map and site location circles are intended to give readers a broad view of where the sites are located. Please consult a tourist map for greater detail.

T0312379

PITTSBURGH

THEN AND NOW®

First published in the United Kingdom in 2016 by
Pavilion
An imprint of HarperCollins*Publishers*
1 London Bridge Street
London SE1 9GF
www.harpercollins.co.uk
HarperCollins*Publishers*
Macken House
39/40 Mayor Street Upper
Dublin 1
D01 C9W8
Ireland

ISBN-13: 978-1-910904-91-6

Printed and bound in China by RR Donnelley APS

Reprinted 2019, 2021, 2023

PICTURE CREDITS
Then Photographs:
Allegheny Conference on Community Development Photographs, Detre Library & Archives,
Senator John Heinz History Center: 36.
Carnegie Library of Pittsburgh: 8, 16, 18, 34, 38, 40, 52, 62 (top), 90, 92, 96, 102, 112, and 130.
General Photograph Collection, Detre Library & Archives, Senator John Heinz History Center: 60.
Library of Congress: 10, 14, 20, 24 (bottom) 30, 39, 43, 44, 48, 50, 56, 62 (bottom), 66, 67, 70, 74 (bottom), 80, 81,
82, 84, 98, 100, 110 (bottom), 114, 116, 118, 120 (bottom), 126, 138 and 139.
Pittsburgh City Photographer Collection, 1901–2002, AIS.1971.05, Archives Service Center, University of
Pittsburgh: 22, 28, 32, 54, 78, 88, 106, 122 and 124.
Pittsburgh History & Landmarks Foundation: 12, 24 (top), 26, 42, 46, 58, 64, 66, 68, 72, 74 (top), 76, 86, 94, 104,
108, 110 (top), 120 (top), 128, 132, 134, 136, 140, and 142.

Now Photographs:
All photographs were taken by Simon Clay and Karl Mondon (Pavilion Image Library) with the exception of
Page 39, Martin Sturgess and page 131, Louise King Sturgess.

Front endpaper map is courtesy of OpenStreetMap contributors (www.openstreetmap.org). Rear endpaper
panorama courtesy of Library of Congress/Detroit Publishing.

ACKNOWLEDGMENTS
Several of our colleagues at the Pittsburgh History & Landmarks Foundation contributed information
(especially in the "Now" captions), obtained photographs, offered advice, helped with mapping the locations
of all the "Now" photographs, and generally expedited things. Our thanks, then, go to Frank Stroker, assistant
archivist; Al Tannler, historical collections director; and Mary Ann Eubanks, former education coordinator. In
addition, we thank Laurie Cohen (Hillman Library, University of Pittsburgh) and Todd Wilson and Helen Wilson,
co-authors of *Pittsburgh's Bridges*, for providing information.

As to picture sources and their personnel, we owe thanks to Miriam Meislik, associate archivist/photograph
curator, Archives Service Center, University of Pittsburgh; Marilyn Holt, Barry Chad, and Gilbert Pietrzak
of the Pennsylvania Department of the Carnegie Library of Pittsburgh; Rebekah A. Johnston, coordinator,
photographic services and Carly Lough, archivist, Senator John Heinz History Center.

PITTSBURGH HISTORY & LANDMARKS FOUNDATION
The **Pittsburgh History & Landmarks Foundation** (PHLF) was founded in 1964 by a group of citizens who
passionately believed that historic preservation, rather than massive demolition, could be a tool for renewing
communities, building pride among residents, and achieving sustainable economic development. After more
than 50 years of work throughout the Pittsburgh region, PHLF has shown that architectural landmarks and
historic neighborhoods are community assets and that historic preservation is a catalyst for urban renewal.
"Through the place, we renew the spirit of the people," says Arthur P. Ziegler, Jr., co-founder and president.
"Historic preservation can be the underlying basis of community renewal, human renewal, and
economic renewal."

PHLF is especially known for its pioneering work in restoring inner-city neighborhoods without dislocating
the people who live there, and for renovating five underutilized Pittsburgh & Lake Erie Railroad buildings into
the mixed-use riverfront development of Station Square, directly across from downtown Pittsburgh. PHLF's
offices and two libraries (the James D. Van Trump Library and Frank B. Fairbanks Rail Transportation Archive)
are located at Station Square. In addition, PHLF has established the Landmarks Preservation Resource Center
in the Borough of Wilkinsburg, adjacent to the City of Pittsburgh. There, professionals offer workshops and
presentations to help people learn about home ownership and financing, restoration techniques, green-
building, energy efficiency, interior design, and gardening, among other topics.

Through its work in preservation and education, PHLF is improving the quality of life for people in the
Pittsburgh region and supporting tourism.

AUTHORS
Walter C. Kidney (1932–2005) was born in Johnstown, Pennsylvania, and was educated in the Philadelphia
area. He worked in publishing as a definer on the Random House Dictionary project and as a writer for
Laurence Urdang, Inc. before making his home in Pittsburgh in the late 1970s. As an architectural historian
with the Pittsburgh History & Landmarks Foundation (PHLF), Kidney authored and edited more than 20
significant publications on local history and architecture, including: *Pittsburgh's Landmark Architecture:
The Historic Buildings of Pittsburgh and Allegheny County* (1997); *Pittsburgh's Bridges: Architecture and
Engineering* (1999); *Henry Hornbostel: An Architect's Master Touch* (2002); and the first edition of *Pittsburgh
Then and Now* (2004). His knowledge was encyclopedic, and his graceful, insightful prose helped people see
the beauty of the built environment.

Louise King Sturgess, a fifth-generation Pittsburgher, has worked for the Pittsburgh History & Landmarks
Foundation (PHLF) since 1981. She has edited more than 25 books on regional history and architecture, and
more than 60 books featuring the poetry, artwork, and essays of students and teachers based on historic
places in the Pittsburgh region. In 2004, Sturgess worked with Kidney on the first edition of *Pittsburgh Then
and Now*. Her work in creating educational programs that bring the history, architecture, and significance
of the Pittsburgh region to life has been recognized by The History Channel, National Trust for Historic
Preservation, Pennsylvania Council for the Social Studies, Pennsylvania Historical & Museum Commission,
and Pittsburgh City Council.

PITTSBURGH
THEN AND NOW®

PITTSBURGH HISTORY &
LANDMARKS FOUNDATION

PAVILION

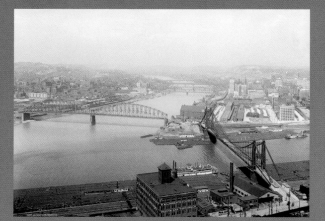

View from Mount Washington, 1913 p. 10

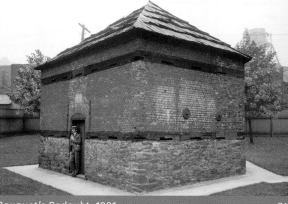

Smithfield Street Bridge, c. 1895 p. 18

Bouquet's Redoubt, 1901 p. 24

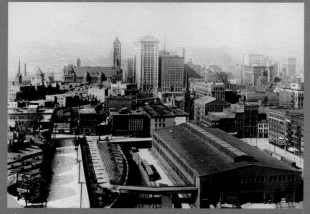

View from Union Station, c. 1910 p. 36

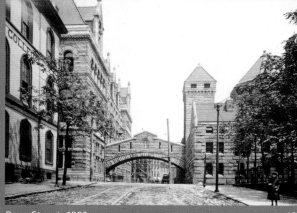

Ross Street, 1893 p. 42

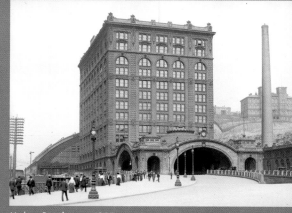

Union Station, c. 1905 p. 50

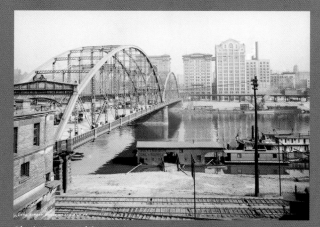

Sixth Street Bridge, c. 1910 p. 56

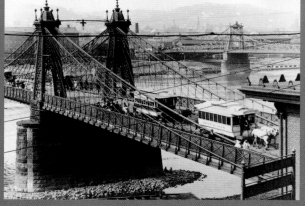

Allegheny River Bridges, c. 1890 p. 62

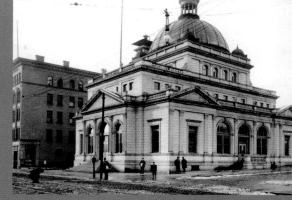

Allegheny Post Office, c. 1900 p. 68

Allegheny Commons, Lake Elizabeth, c. 1925 p. 70

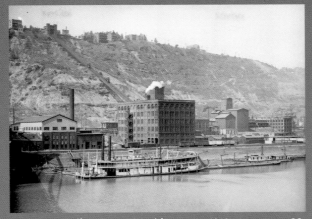

Duquesne Incline, Mount Washington, c. 1910 p. 80

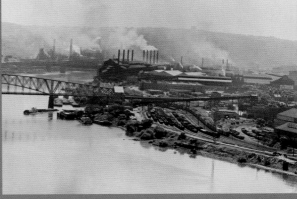

J&L Plant, South Side Works, c. 1900 p. 90

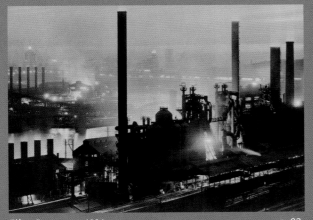

Eliza Furnaces, 1931 p. 92

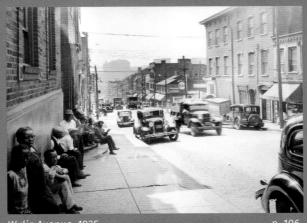

Wylie Avenue, 1935 p. 106

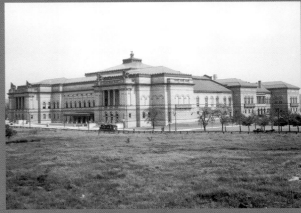

Carnegie Institute, c. 1907 p. 118

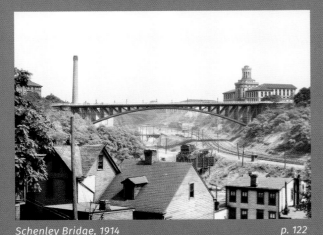

Schenley Bridge, 1914 p. 122

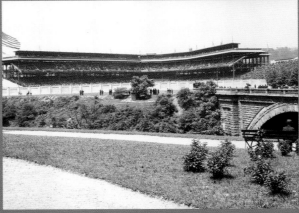

Forbes Field, c. 1910 p. 126

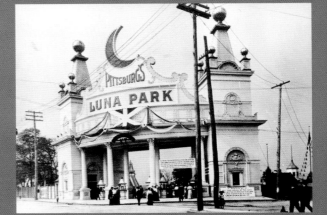

Luna Park, c. 1905 p. 130

PITTSBURGH
THEN AND NOW INTRODUCTION

Pittsburgh and nature have had a peculiar relationship from the beginning. Two rivers, the Allegheny coming from the north and the Monongahela coming from the south, join at the Pittsburgh Point to form the Ohio, which flows westward about 980 miles to the Mississippi. The three rivers are framed by plains, hills, and bluffs, and between the tributary rivers are plateaus and ravines, all remnants of an ancient river delta. Differences of level within the city amount to about 500 feet. The present composition of the terrain is due to events long past and widely dispersed, and to talk of them requires a description of plate tectonics, a journey over time from below the equator to the fortieth north parallel, a few Ice Ages, and the formation of a ten-foot coal seam.

From this geography, Pittsburgh history has emerged. Summing it up, we might begin with the clash in 1754 of English- and French-speaking peoples at the Point, leading to the French and Indian War and eventual victory for the English-speakers. Then, in 1758, the naming of Pittsburgh by the victorious General John Forbes, who ordered that Fort Pitt be built. Both the fort and garrison town were named after British statesman William Pitt the Elder, Earl of Chatham. Pitt devised the military strategy that allowed the British to defeat the French in this region and around the world. The discovery of coal and other minerals led to a growing industrial presence, beginning with glassmaking in 1797. The role of Pittsburgh around 1800 was "Gateway to the West," a place for building and outfitting flatboats and keelboats. The *New Orleans*, the first Western River steamboat, made her maiden journey from Pittsburgh to the Louisiana port in 1811. All-rail transportation from Philadelphia arrived in 1852 and continued westward. The processing of iron, at first smelted

elsewhere, was smelted in Pittsburgh beginning in 1859. In 1875, the first steel rail in America was produced using the Bessemer Process at Andrew Carnegie's Edgar Thomson Works in Braddock, less than ten miles from Pittsburgh's Point, and in operation continuously since then.

Nature gave opportunities to Pittsburgh, but Pittsburgh in the nineteenth and twentieth centuries was hardly in harmony with nature. The bituminous coal that gave the region its power laid a heavy coating of soot over everything, coming from locomotives, steamboats, industrial fires, and domestic fires. The beehive coke oven, which produced hot-burning blast-furnace fuel, released a multitude of volatiles into the air well into the 1920s. Such an ordinary commodity as drinking water was dangerous until around 1910. And of course taming the terrain was a struggle, an affair of bridges, tunnels, retaining walls, inclined planes first for coal and later for hill-dwellers, the erection of notorious public steps that climbed a hundred feet or so, and the grading and paving of many little streets. In many cases on the slopes a street would exist only on paper, with a flight of steps of planks or concrete as the means of ascent. But there was something undeniably romantic about the terrain, about the vast spaces of the river valleys seen from a hilltop, and the growth of wild vegetation wherever allowed. Sheltered by the changing contours of the land, many Pittsburgh neighborhoods were able to thrive and retain their rich ethnic character.

Toward 1900 the City Beautiful movement that was capturing the national imagination began influencing the development of Oakland, several miles east of downtown.

Mary Schenley, Pittsburgh's most famous expatriate, donated 300 acres of land for a major urban park, and Andrew Carnegie, rich in steel money, donated funds for a magnificent cultural institution. Franklin Nicola bought and sold land so as to encourage the development of the Oakland Civic Center, a whole new campus for the University of Pittsburgh, and the model residential neighborhood of Schenley Farms. Edward Manning Bigelow, the city's director of public works, created a direct road to Pittsburgh's developing East End, a park system, and a much-needed water filtration system.

The celebrated Pittsburgh Renaissance of the 1950s revived a city neglected in the Depression and then hard-driven by war. It cleaned up the air and the rivers and gave the city a new image, even while Jones & Laughlin, within sight of downtown, was erecting a giant open-hearth plant.

The bright new image of Pittsburgh, however, was attained at some cost. Handsome old buildings and even whole neighborhoods were demolished in order to rebuild according to new theories of housing, merchandising, and traffic management. In 1964 the Pittsburgh History & Landmarks Foundation was founded to prove that rebirth could be achieved through restoration and adaptive reuse.

Entering the twenty-first century, Pittsburgh is reinventing itself once again. Now that the air is clean and heavy industry is gone, the ailanthus and her companions have volunteered enthusiastically to cover the hillsides and river edges. Deer and wild turkey inhabit woods within a mile of the Golden Triangle, Pittsburgh's central business district;

peregrine falcons hunt among skyscrapers; and, after an absence of 200 years, bald eagles have returned to nest in Pittsburgh's Hays neighborhood. About 305,000 people live within the fifty-five square miles of the city limits, working out to nine people per acre: almost sylvan. Pittsburgh is gaining a reputation as a "green" city, not only because of the wooded landscape, but because of the environmentally friendly buildings that are being constructed. Funds are being raised to restore the city parks, develop the riverfronts, and light the bridges. A center for business, finance, technology, education, health and human services, arts and culture, sports and recreation, Pittsburgh is a desirable place to be.

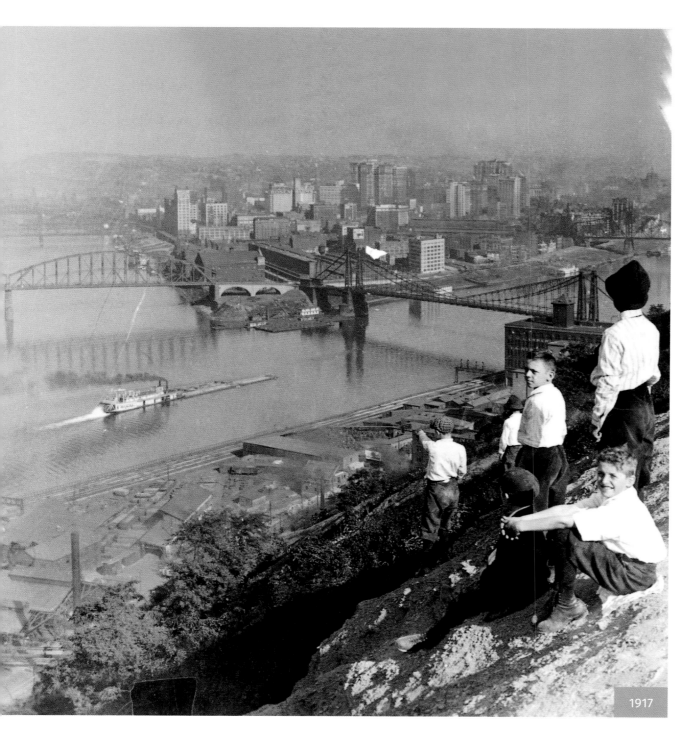

1917

VIEW FROM MOUNT WASHINGTON
Where the Allegheny and the Monongahela meet

LEFT: Young Pittsburghers of 1917 look over their city from the edge of Mount Washington. They see the Allegheny River, coming in from the north and east on the left; the Monongahela, coming in from the south and east on the right; and their formation of the Ohio at the Pittsburgh Point. The Point area itself is made up of piecemeal industrial development, but beyond are the business towers at the heart of commercial Pittsburgh. The highest among those visible include the Farmers Deposit National Bank of 1902 and First National Bank of 1912 (both center) and the Frick Building (center right). The steam stern-wheel towboat, pushing its barges, is a familiar sight along what has always been a busy river and river port.

RIGHT: Much has changed in the Golden Triangle. The Point is now a park, the old bridges are gone, and the meeting of the rivers is marked by a fountain that was dedicated in 1974. Beyond Point State Park, new towers mark the Pittsburgh Renaissance, which began in 1946. One building is undisputedly the tallest: the 841-foot U.S. Steel Building, completed in 1971, and now also the headquarters of UPMC (University of Pittsburgh Medical Center). Today's skyline owes its appearance to Harrison & Abramovitz; Skidmore, Owings & Merrill; Philip Johnson; HOK; and other prominent American architectural firms.

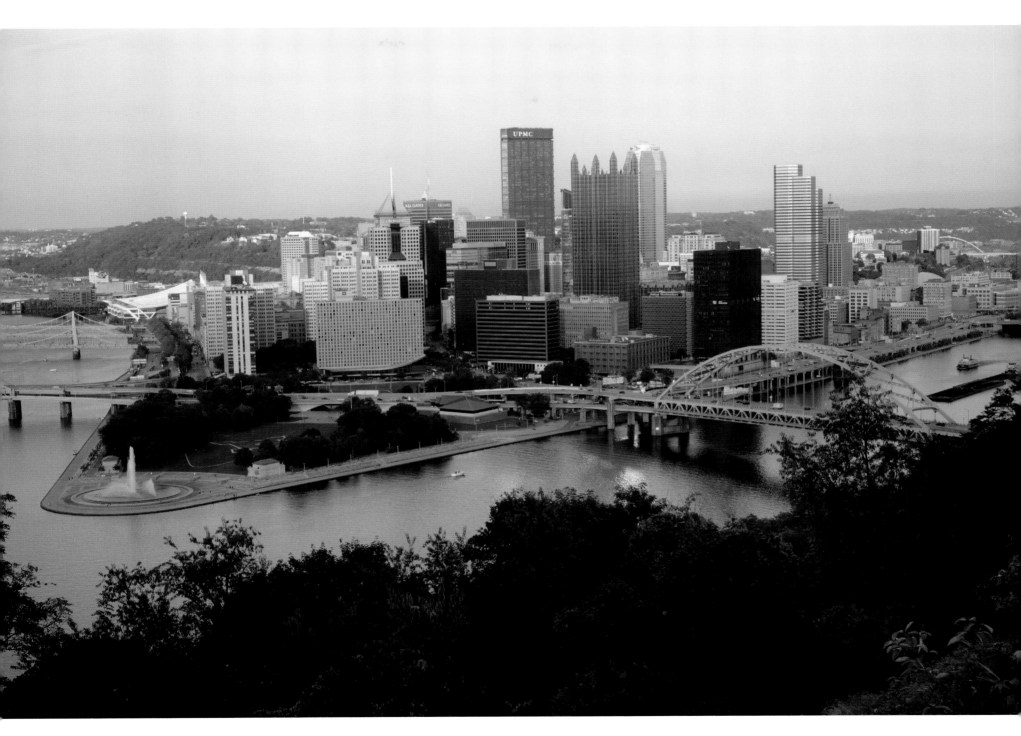

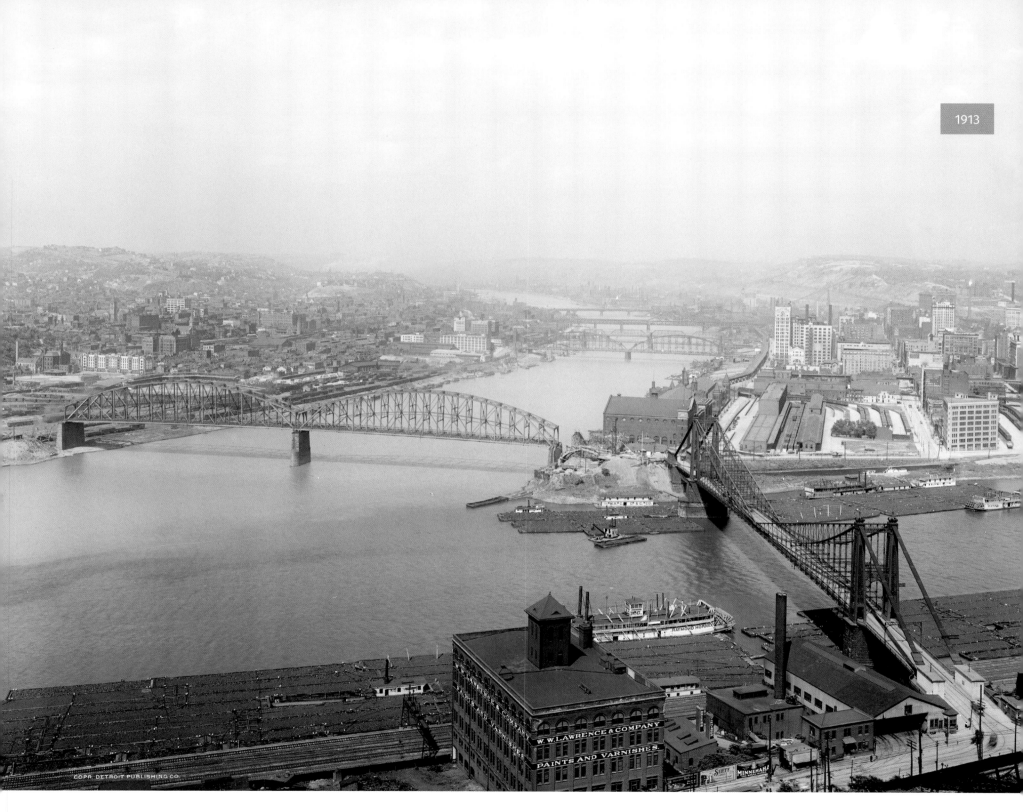

1913

W.W. LAWRENCE & COMPANY
PAINTS AND VARNISHES.

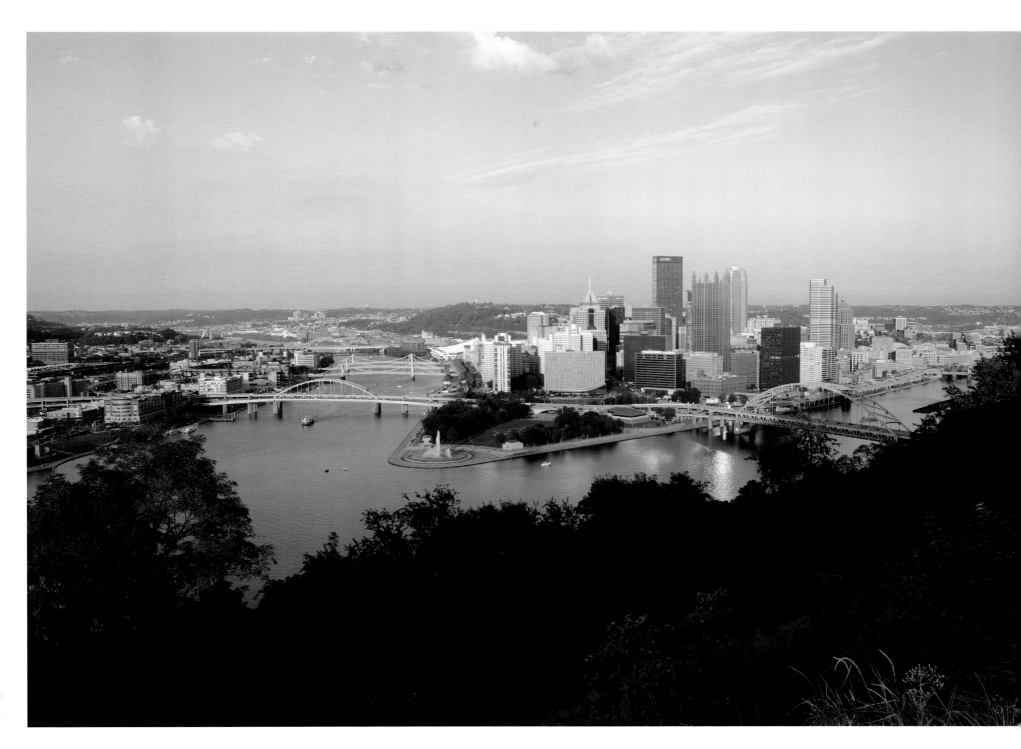

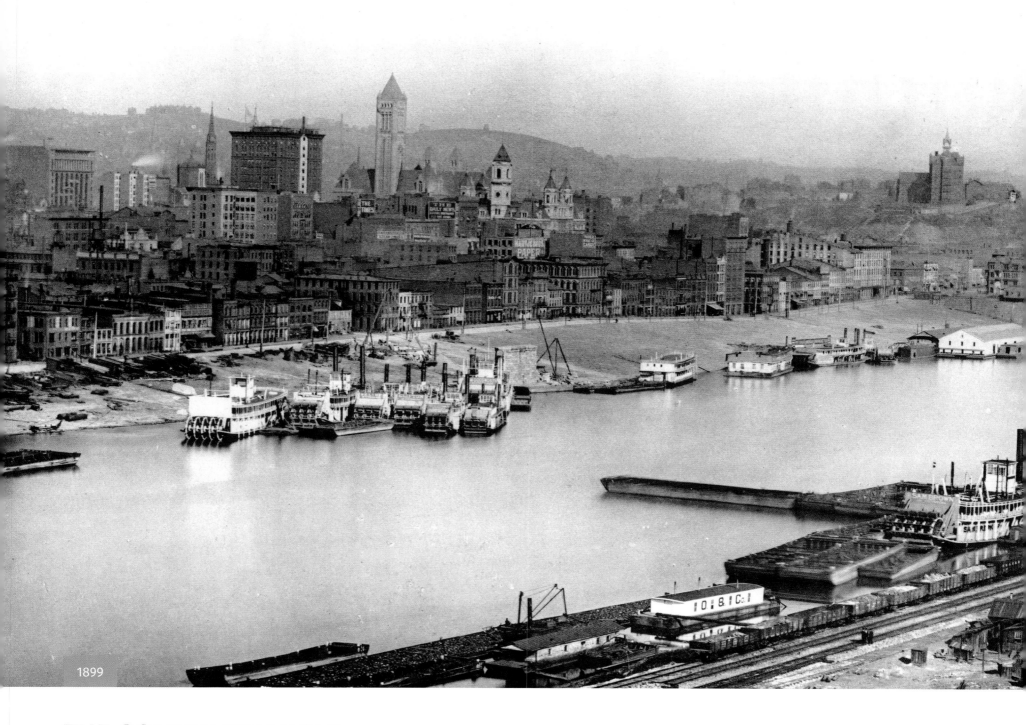

1899

THE GOLDEN TRIANGLE

A skyline dominated by the Allegheny County Courthouse

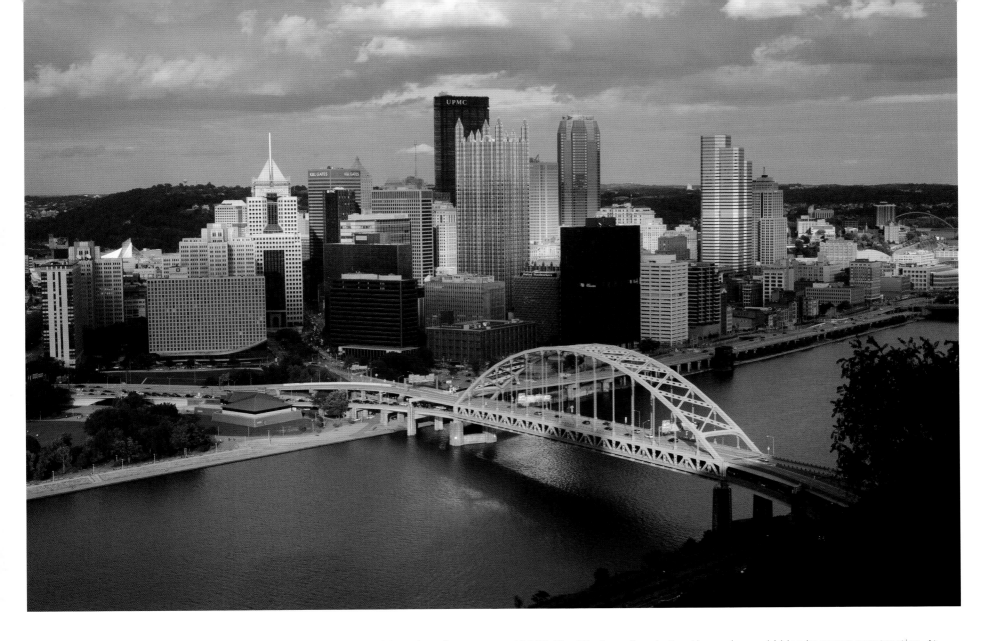

LEFT: A closer look at the Triangle in 1899 shows a downtown in transition. The tall, slender tower of H. H. Richardson's Allegheny County Courthouse dominates the town as it has since 1888, but the steel-framed, elevator-serviced skyscraper is coming to rival its height: the Carnegie Building (to the left of the courthouse) and the Park Building (further left). The Fourth Avenue Post Office on Smithfield Street (to the right of the courthouse) is also noticeable. Duquesne University's Administration Building and Chapel of 1884 stand on the bluff at the far right. The Monongahela Wharf, stone-paved and sloping to the river, offers its usual variety of drays, towboats, and wharf boats. In the foreground, on the south side, coal barges are tied up.

ABOVE: The Allegheny County Courthouse is now hidden by newer construction. At center, the UPMC/U.S. Steel Tower peeks above the forty-story glass tower of PPG Place. BNY Mellon Center is the city's second-tallest structure. One Oxford Centre, a cluster of octagons, stands in front of the Grant Building, a set-back skyscraper of the 1920s. Fifth Avenue Place, with its distinctive split top and mast, rises above several historic city districts. The Monongahela Wharf has changed from a sloping, paved embankment to a double-decked parkway. The Fort Pitt Bridge, opened in 1959, was the first double-decked tied-arch bridge and is the westernmost Monongahela River bridge. The black roof and red-brick walls of the Fort Pitt Museum are visible in Point State Park. The museum opened in 1969 in a reconstructed bastion of Fort Pitt. Both the museum and bridge recall the founding and naming of Pittsburgh in 1758.

14

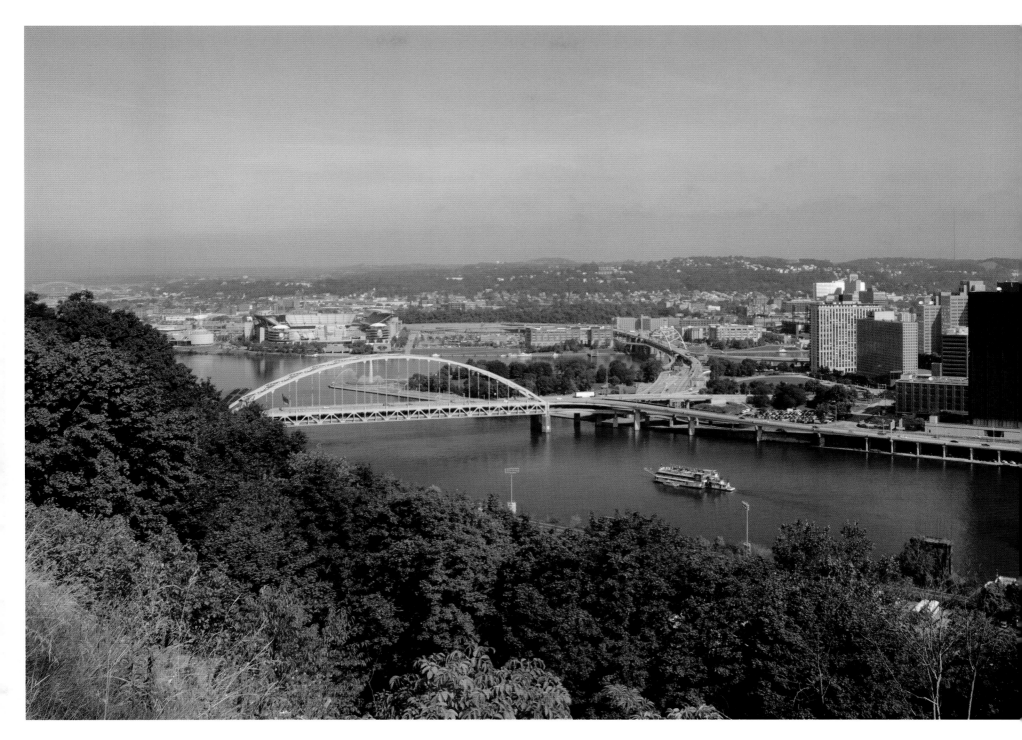

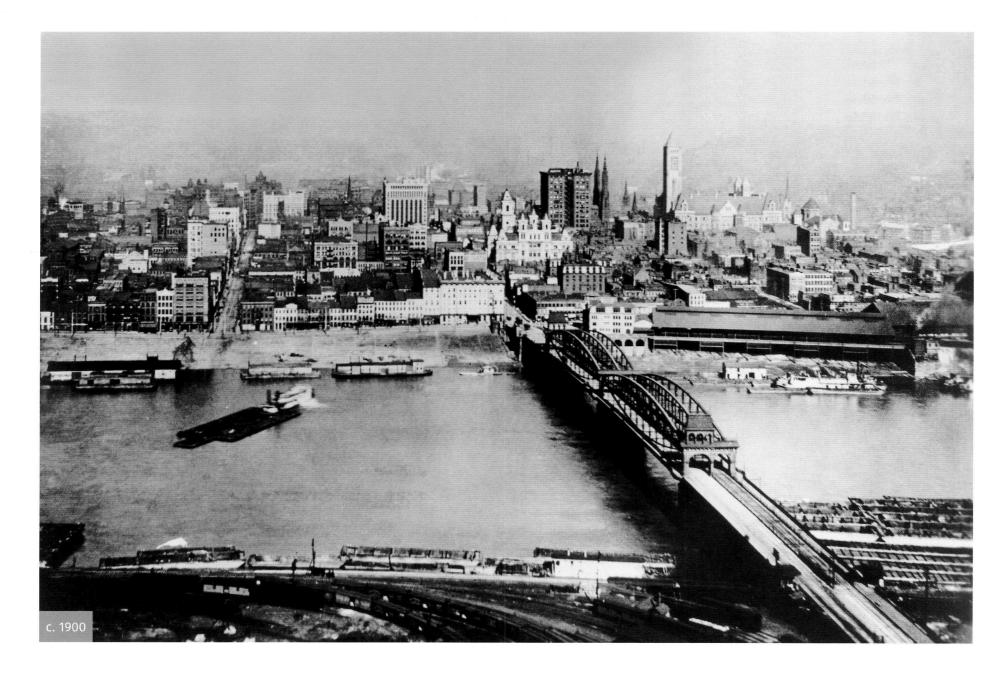

c. 1900

THE GOLDEN TRIANGLE

From a time when Pittsburgh was the "Workshop of the World"

ABOVE: This is another 1900-period view of the Triangle. The Smithfield Street Bridge of 1883 still has its original portals, but has been widened to the right. Just beyond the bridge is the Baltimore & Ohio passenger station of 1888, which lasted until 1955. Further down Smithfield Street is the towered and turreted Fourth Avenue Post Office of 1891. Near the Allegheny County Courthouse and Jail appear the spires and central cupola of St. Paul's Roman Catholic Cathedral, which remained until 1904. In the foreground are the tracks of the Pittsburgh & Lake Erie Railroad (P&LE RR).

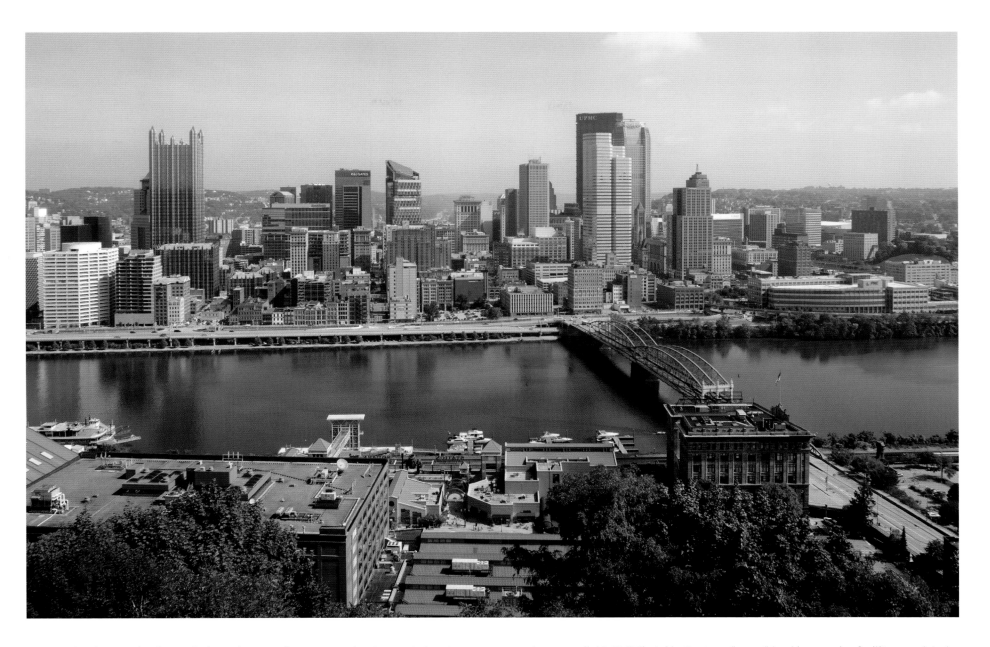

ABOVE: The sheer scale of twentieth- and twenty-first-century development downtown can now be seen, as the Allegheny County Courthouse edges into view in between the One Oxford Centre tower, to its left, and the Grant Building, to its right. The Tower at PNC Plaza (just left of center) is one of the world's "greenest" skyscrapers. The sloping roof is covered with solar panels and is angled to the southeast to capture maximum sunlight. PNC Firstside Center, a "green" banking-service facility completed in 2000, hugs the Monongahela River shore to the right of the Smithfield Street Bridge. The bridge, with its fortress-like portals from 1915 displaying the City coat of arms, connects downtown to Station Square (foreground) and the South Side. The Pittsburgh History & Landmarks Foundation initiated the Station Square development in 1976.

SMITHFIELD STREET BRIDGE

Pittsburgh's oldest existing river bridge

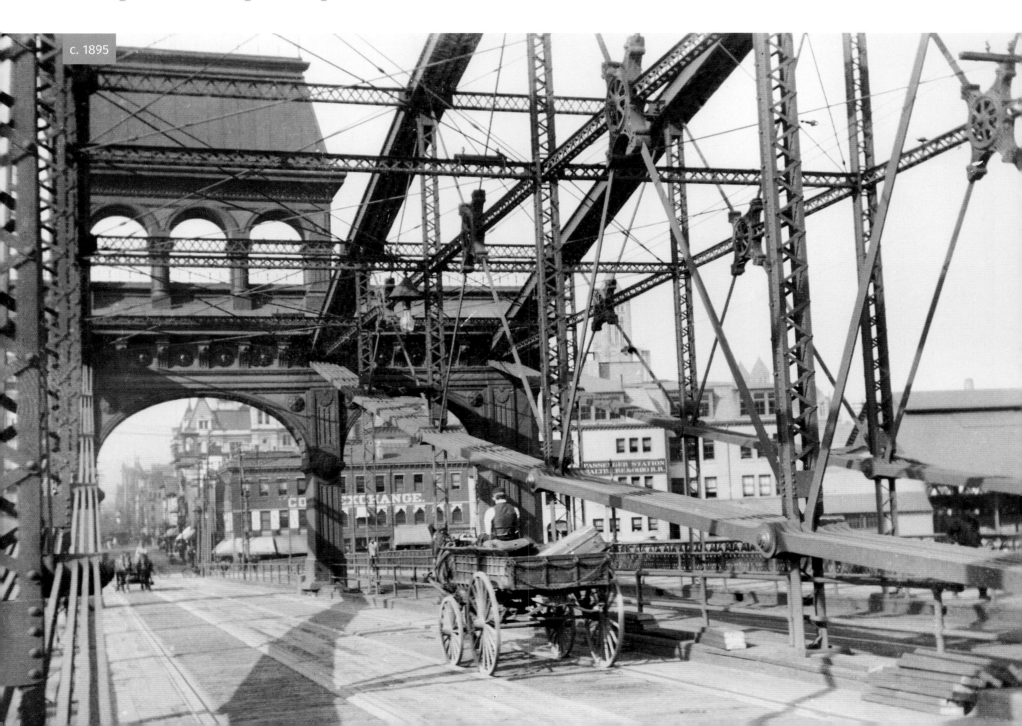

c. 1895

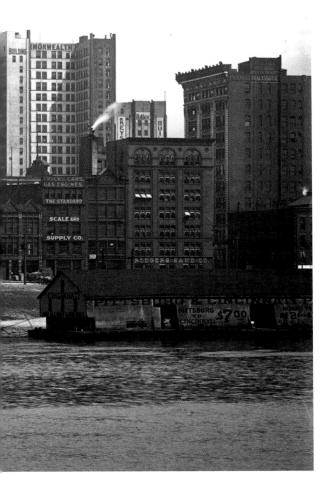

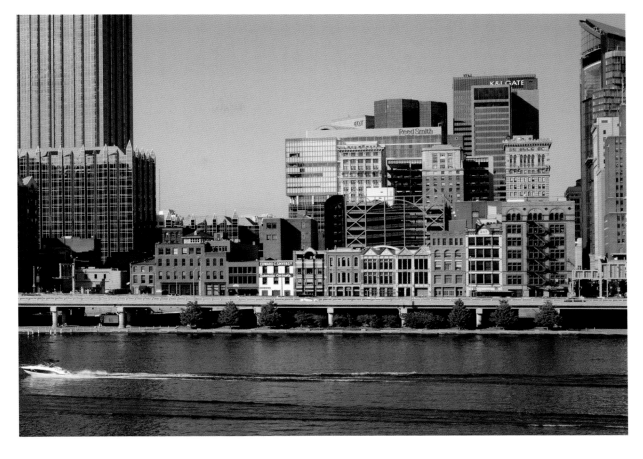

LEFT: This is Water Street in 1912. Compared with the tall new Fourth Avenue buildings on the skyline further inland, bright in their granite and terra cotta, the lower and darker ones that line Water Street seem vestiges of another age. The older buildings from after the fire of 1845, which took out a third of the Triangle, offer a range of styles: plain vernacular, Italianate, Queen Anne, and Romanesque. The four-story building at the center belongs to the Monongahela River Consolidated Coal and Coke Company, "the Combine." This was a group of about a hundred entities involved in the shipping of coal that was successful between 1899 and 1915, at which point it suddenly went out of business due to competition from the railroads.

ABOVE: This view from across the Monongahela River roughly reveals the architectural history of the Triangle, with the buildings getting newer and higher the further one looks inland: from the small-scaled Victorian waterfront buildings to the light and fancy terra cotta of the 1900s, to the composed masses and mellow brick of the 1920s, and the undetailed glass-box aesthetic of modernism. The most massive building in this photo is PPG Place—designed by Philip Johnson of Johnson & Burgee and completed in 1984—clad in PPG Solarban 550 Window Glass. To the far right is the sloping roof of The Tower at PNC Plaza, designed by Gensler and completed in 2015. Three PNC Plaza, completed in 2009 and also designed by Gensler, includes the law offices of Reed Smith, the Fairmont Pittsburgh Hotel, condominiums, and retail. A thirty-nine-story skyscraper designed by William Lescaze & Associates in 1968 rises behind and houses the law offices of K & L Gates.

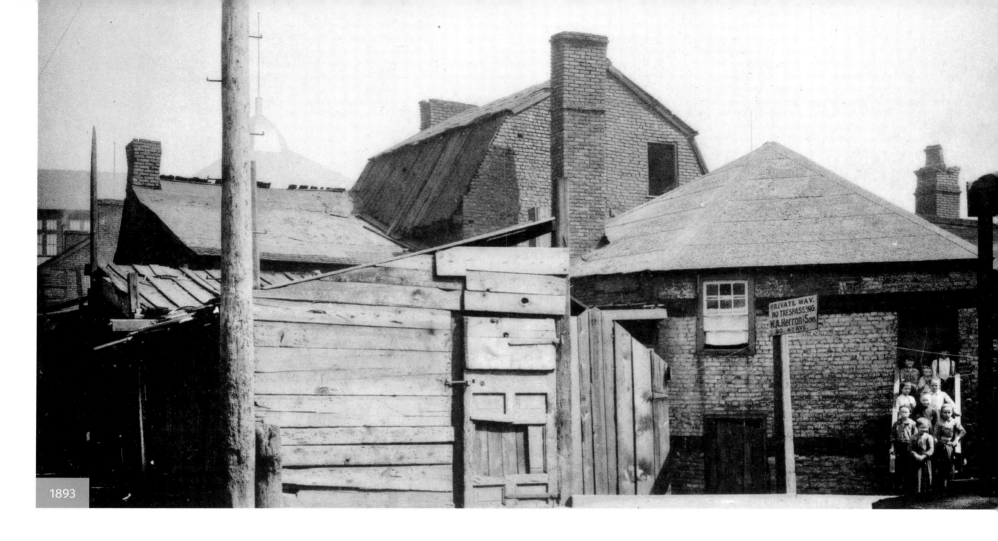

1893

BOUQUET'S REDOUBT
Preserved thanks to the work of pioneering women

RIGHT AND ABOVE: Apart from any buried foundation work here or there, the little building on the right is the sole eighteenth-century architectural survivor in downtown Pittsburgh: Bouquet's Redoubt, also called the Block House. As it happened, no shot has ever been fired at it in anger. Built in 1764 by Colonel Henry Bouquet, it missed the French and Indian War and the Pontiac Uprising of 1763. Neither the Revolution nor the Whiskey Rebellion of 1794 approached it. Its greatest peril came from the Pennsylvania Railroad that was expanding into the Point area in the early 1900s. The southern façade of the Block House in 1893 is shown above, after it had been adapted as a trading post, then as a private home for more than 100 years, and finally as a rented tenement.

1901

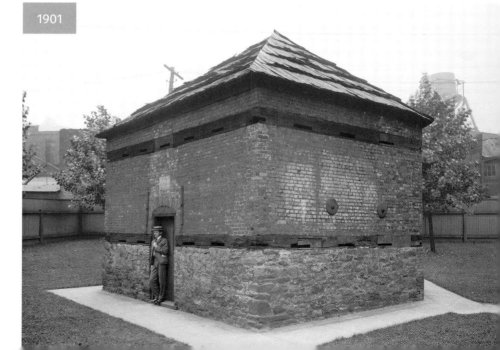

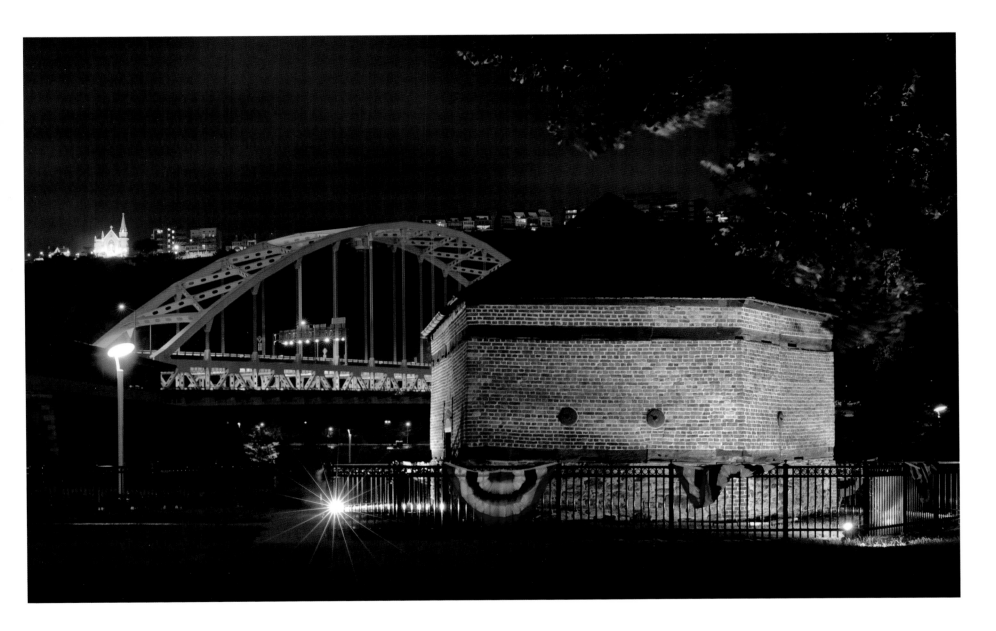

ABOVE: The northern façade of the five-sided Block House is shown. The restored military redoubt of 1764 has remained in its original location and is now within Point State Park, close to the Fort Pitt Museum and Fort Pitt Bridge, and within sight of Mount Washington, where St. Mary of the Mount Church crowns the 400-foot slope. Since 1895, the Block House has been open as a museum, free to the public. The story of its survival is the first chapter in Pittsburgh's pioneering work in preservation.

In 1894, the Pittsburgh Chapter of the Daughters of the American Revolution (DAR) convinced Mary Croghan Schenley, Pittsburgh land heiress and expatriate, to donate the Block House. The DAR then restored the Block House as a defensive redoubt and led a ten-year legislative battle to create state laws to protect it—all before women won the right to vote in 1920. The DAR was among the first to envision a park at the Point.

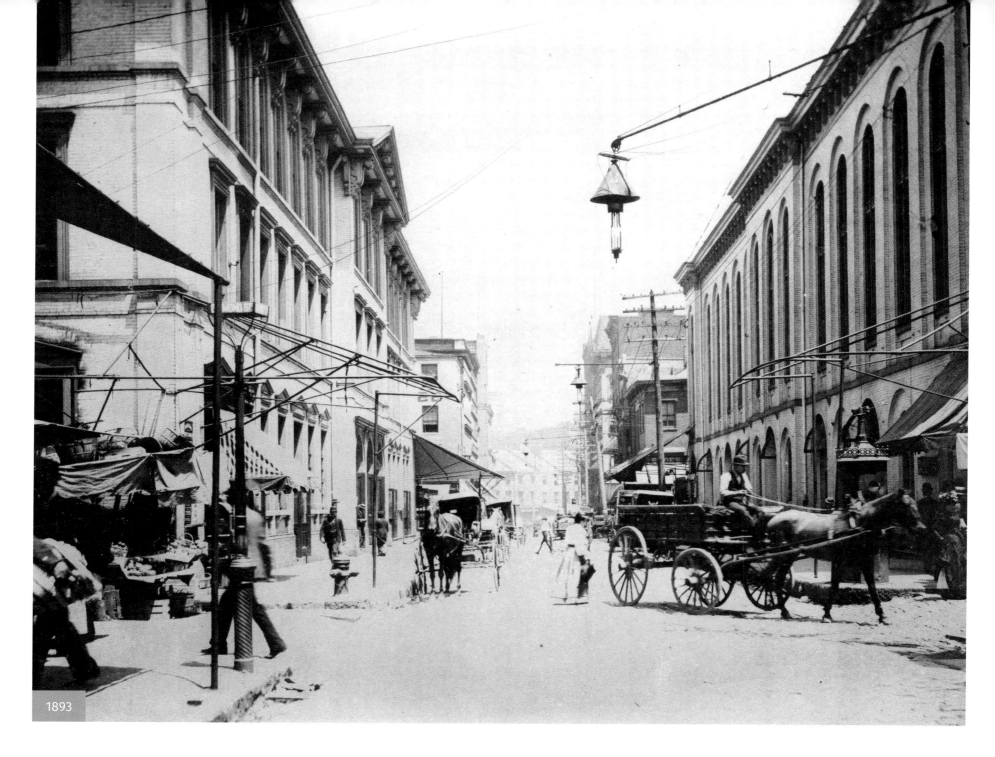

1893

MARKET STREET

The market house has long since disappeared from Market Street

26

LEFT: The trading settlement that was called Pittsburgh after 1758 was surveyed in 1784 for the Penn family, who were still proprietors of the area. Surveyors George Woods and Thomas Vickroy provided, among other things, for a large market square. Known originally as the Diamond—an Irish usage—it contained the first little Allegheny County Courthouse as well as market stalls. Then, in the 1850s, it was built up with two structures: the Market House (left) and the City Hall (right). This view from 1893 is looking down Market Street toward Liberty Avenue.

ABOVE: The old Diamond and crossroads are more open these days and have become one of Pittsburgh's most popular places to relax. Market Square contains a miscellany of construction, from postfire buildings from around 1850 to outlying portions of the cold crystalline architecture of PPG Place. In between are a host of mercantile fronts. Rising above and beyond Market Square on the left is the former Diamond National Bank of 1905 with its copper cheneau. Just right of center is EQT Tower with its curved "bridge" motif partially visible, designed in 1984 by Kohn Pedersen Fox. The glass-clad Three PNC Plaza is diagonal from a group of historic buildings, including "Market at Fifth" (retail and residential) and the Market Street Grocery.

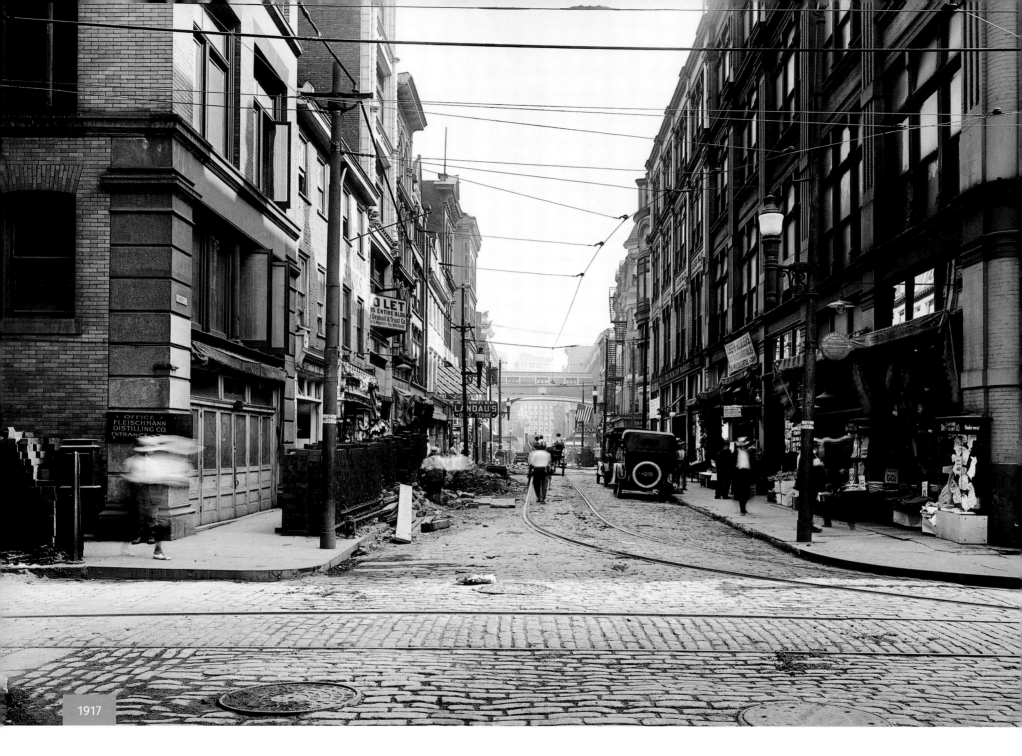

1917

MARKET STREET / PPG PLACE

Water is now at the center of PPG Place, whether summer or winter

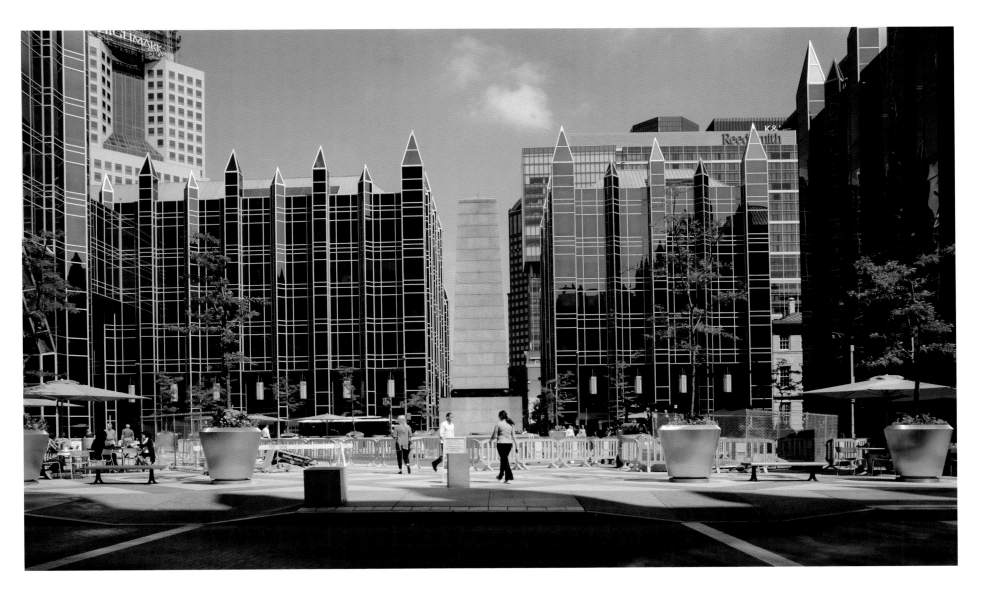

LEFT: Here is a 1917 view looking northward along Market Street from Third Avenue. Most of the architecture is Victorian, and one or two buildings may even have survived the fire of 1845. Market Street is spanned by the footbridge of the new Diamond Market House, which arched over both Diamond and Market streets, and far away is the diagonal of Liberty Avenue.

ABOVE: Market Street is now closed off between Third and Fourth avenues, and a new plaza has come into existence. Although New York architect Philip Johnson conceived

PPG Place as a cool, unified architectural statement, the one-acre plaza has been transformed into a popular urban space with a spectacular choreographed fountain in the summer, and the million-dollar MassMutual Pittsburgh Ice Rink in the winter. This photo was taken during the conversion from fountain to ice rink. At right, notice the sliver of a three-story sandstone building with a red roof. Designed in 1836, Burke's Building was Pittsburgh's first office building; it survived the Great Fire of 1845 and, in 1996-97, was among the first historic buildings in Pittsburgh to be renovated according to "green" energy-conservation principles.

LIBERTY AVENUE

Marking the southern boundary of the Penn-Liberty Cultural District

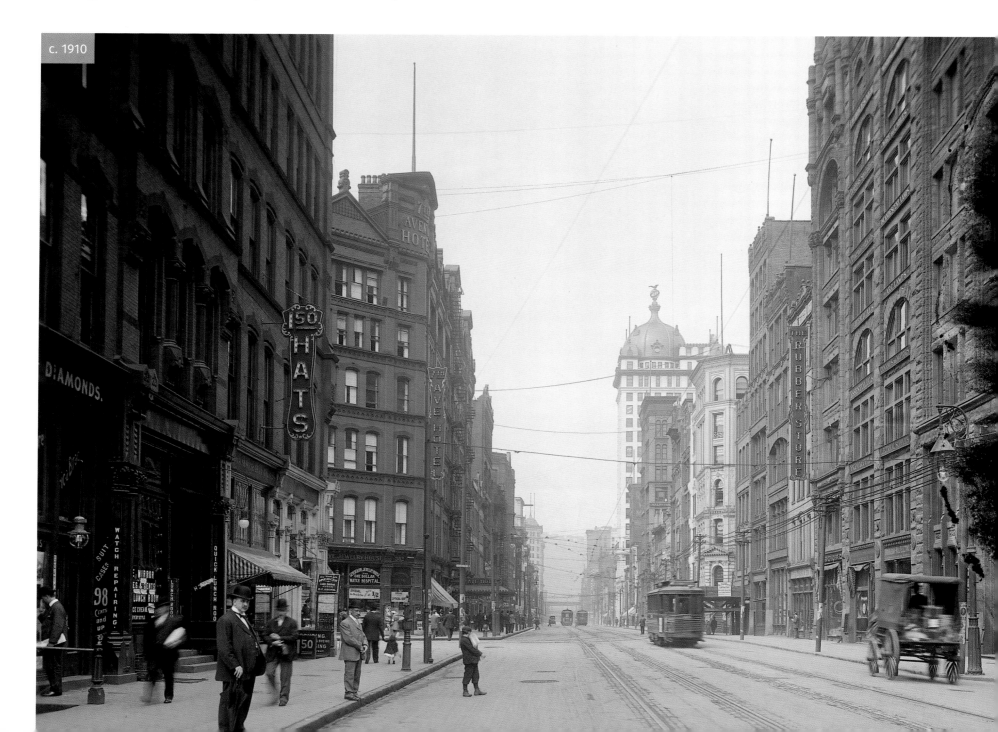

c. 1910

LEFT: Liberty Avenue looking west, around 1910. The Woods-Vickroy survey of 1784 created two street grids in the Triangle, a larger one with streets parallel or perpendicular to the Monongahela River and a smaller one with streets parallel or perpendicular to the Allegheny River. Liberty Avenue was the junction, like a seam connecting two pieces of tartan. The awkwardness that resulted is evident to the left: in the left foreground is a portion of the Triangle Building of the 1870s, and down from it is the obtuse angle of the Seventh Avenue Hotel. Across Liberty is the Richardson Romanesque Ewart Building, built in 1891 for a wholesale grocer, and the Keenan Building of 1907, with its Prussian helmet capped by an eagle in flight.

BELOW: Here the street scene is familiar and welcoming, free from dramatic change. This is the southern boundary of the Penn-Liberty Cultural District in Pittsburgh, both a locally legislated historic district and a federally designated National Register Historic District. Galleries, theaters, restaurants, offices, schools, and loft apartments fill the historic buildings. The nonprofit Pittsburgh Cultural Trust and Pittsburgh Downtown Partnership are both headquartered in this stretch of Liberty Avenue. The Triangle Building is on the left and is part of the Pittsburgh Central Downtown National Register Historic District. The Keenan Building is hidden from view. Victorian commercial architecture predominates:

a little cast-iron Italianate and the 1890-period Richardson Romanesque that the courthouse building made fashionable. The August Wilson Center, named for the Pittsburgh-born Pulitzer Prize-winning African American playwright, Harris Theater, Benedum Center for the Performing Arts, Cabaret at Theater Square, O'Reilly Theater, Heinz Hall for the Performing Arts, and Byham Theater are all within the Penn-Liberty Cultural District.

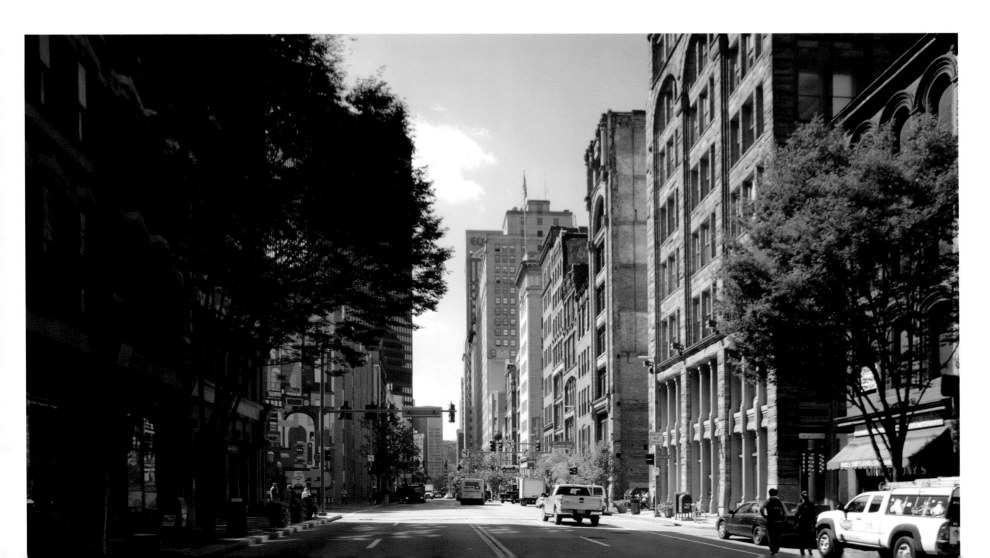

1915

PENN AVENUE

Former site of The Miles vaudeville theater

ABOVE: Parallel to Liberty Avenue and closer to the Allegheny River is Penn Avenue, a street that is rather narrow and is one-way sometimes, but that connects the Triangle with a multitude of easterly neighborhoods: the Strip, Lawrenceville, Bloomfield, Garfield, Friendship, East Liberty, Point Breeze, Homewood, and over the city line to Wilkinsburg. This is Penn Avenue in 1915 looking west past the intersection with Seventh Street. The Miles was a vaudeville house, one of the five theaters in a four-block area mostly occupied by commerce.

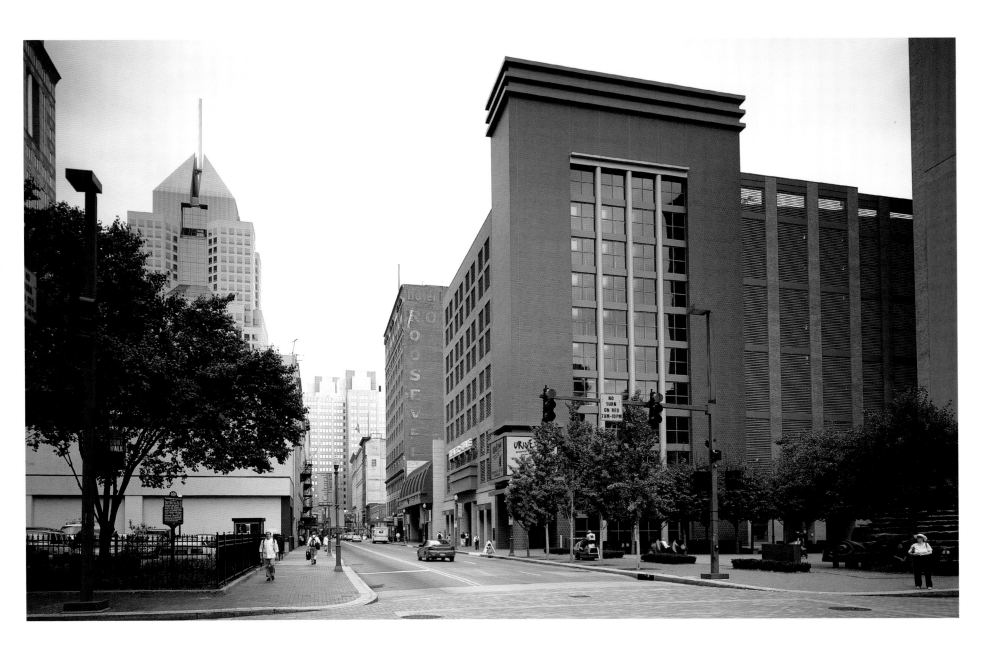

ABOVE: In place of the Miles Theater is Katz Plaza of 1999, landscaped by Daniel Urban Kiley with sculpture by Louise Bourgeois. It is a remarkable refuge, with linden trees, a bronze fountain cascade twenty-five feet high, and three pairs of benches in the form of eyeballs. Michael Graves, architect for Katz Plaza, also designed the colorful Theater Square Building, which opened in 2003, and the adjacent O'Reilly Theater, which opened in 1999 for the Pittsburgh Public Theater. Theater Square includes a cabaret theater, a restaurant, a box office, and a parking garage. On the left side of the street is the rear of Heinz Hall, home to the Pittsburgh Symphony Orchestra. In the distance is Fifth Avenue Place, with its distinctive split top.

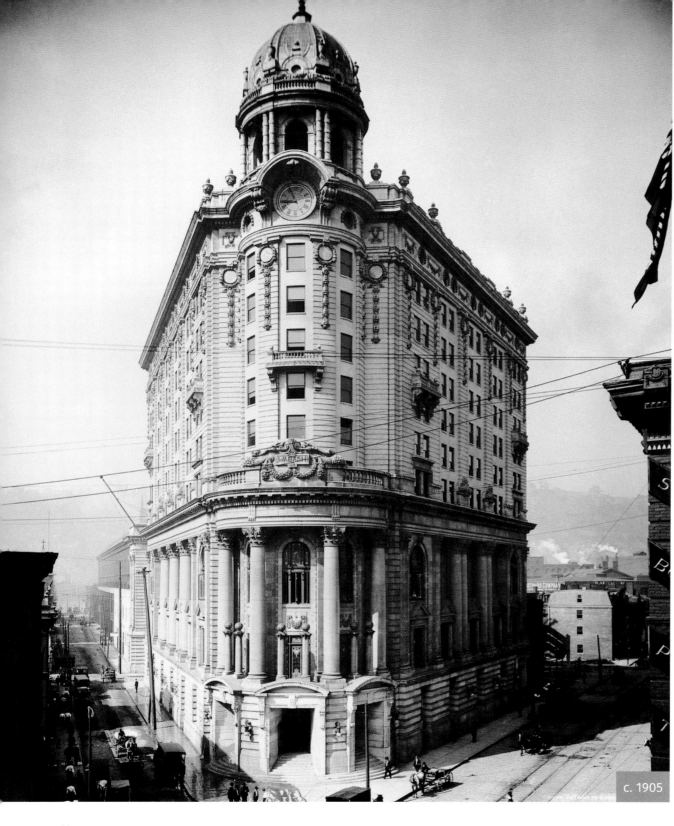

c. 1905

WABASH-PITTSBURGH TERMINAL / FOUR GATEWAY CENTER

A grandiose Beaux-Arts terminal built to rival the Pennsylvania Railroad

LEFT: The Wabash-Pittsburgh Terminal Railway was a vainglorious attempt to gain the sort of access to the Triangle that the Pennsylvania Railroad, its subsidiaries, and the Baltimore & Ohio had previously been enjoying. Realizing the dream of George Jay Gould required a branch off an existing main line sixty miles away, two long tunnels with bad ventilation, a two-track bridge over the Monongahela, a yard area with a constricted throat, storage tracks thirty-five feet above the streets, a narrow trainshed, and this grandiose structure in the Beaux-Arts style, with an entrance on Liberty Avenue. Starting operations in 1904, the Wabash was in receivership in 1908. The terminal building, designed by Theodore Link of St. Louis, was demolished in 1954.

RIGHT AND BELOW: Four Gateway Center, a glass and stainless steel commercial office building, marks the site of the Wabash-Pittsburgh Terminal. Designed in 1958–60 during the city's Renaissance, it is the most elegant of Harrison & Abramovitz's Pittsburgh buildings. Along with the UPMC/U.S. Steel Tower, Four Gateway Center represents the firm's best work here. It is the first in a group of distinguished Gateway Center buildings on Stanwix Street, and is included in the Pittsburgh Renaissance National Register Historic District. The Stanwix-Street façade of Four Gateway Center is seen beyond the glass bridge (below) connecting One and Two PPG Place on either side of Fourth Avenue; the west end of Fourth Avenue terminates at Stanwix Street.

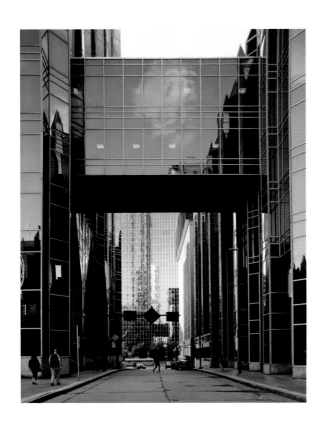

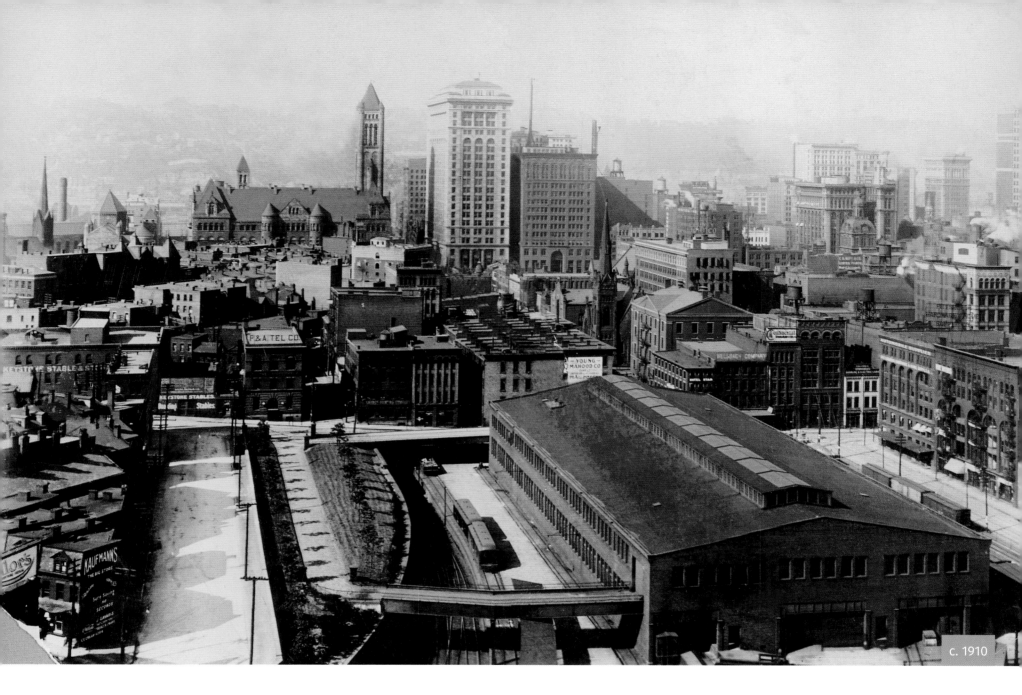

c. 1910

VIEW FROM UNION STATION / THE PENNSYLVANIAN

The Frick Building was the first to surpass the Allegheny County Courthouse tower

ABOVE: This is a view southward from Union Station, around 1910, as the Allegheny County Jail had the additions completed in 1908. The courthouse tower no longer dominates the scene, being boldly confronted by the Frick Building of 1902 directly across Grant Street. Grant Street itself is still an aborted thoroughfare, with a Pennsylvania Railroad freight shed across its axis and no modern development as of yet.

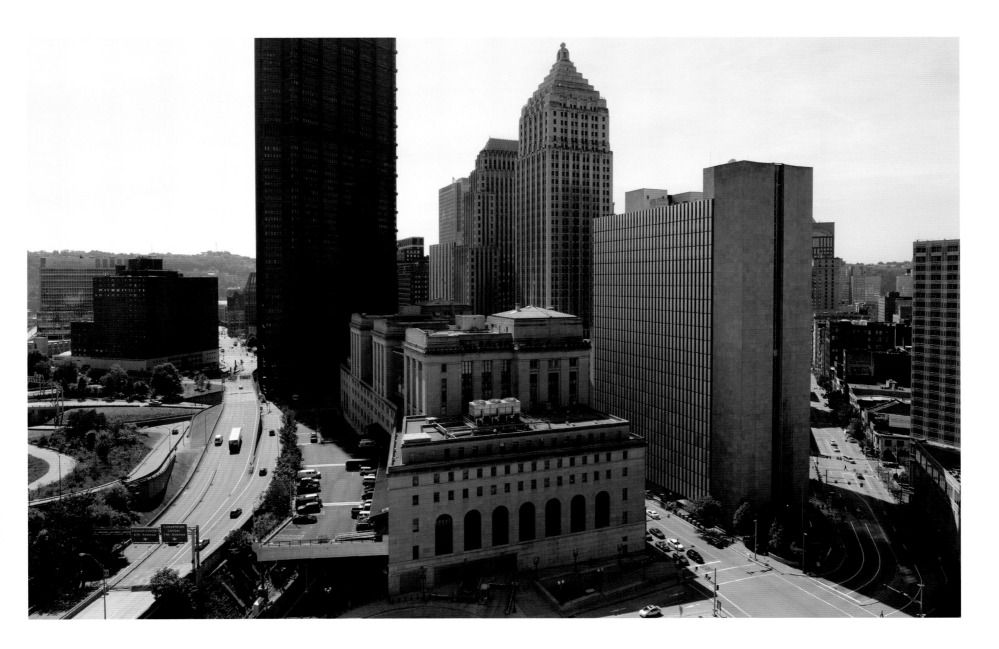

ABOVE: The scale of the southward vista from Union Station (now The Pennsylvanian) has been greatly augmented, and almost nothing can be recognized from the previous scene; indeed, only one corner of the courthouse is visible in both. The tallest building is the UPMC/U.S. Steel Tower. Toward the right, crowned by a ziggurat, is the Gulf Building, now Gulf Tower, which in 1932 was the tallest building in Pittsburgh at 582 feet. To its left is the Koppers Building of 1929. In the foreground is the U.S. Post Office and Courts Building of 1934, which occupies some of the land where the freight station had been. Opposite that rises the modern slab of the William S. Moorhead Federal Building. Liberty Avenue curves behind the Federal Building.

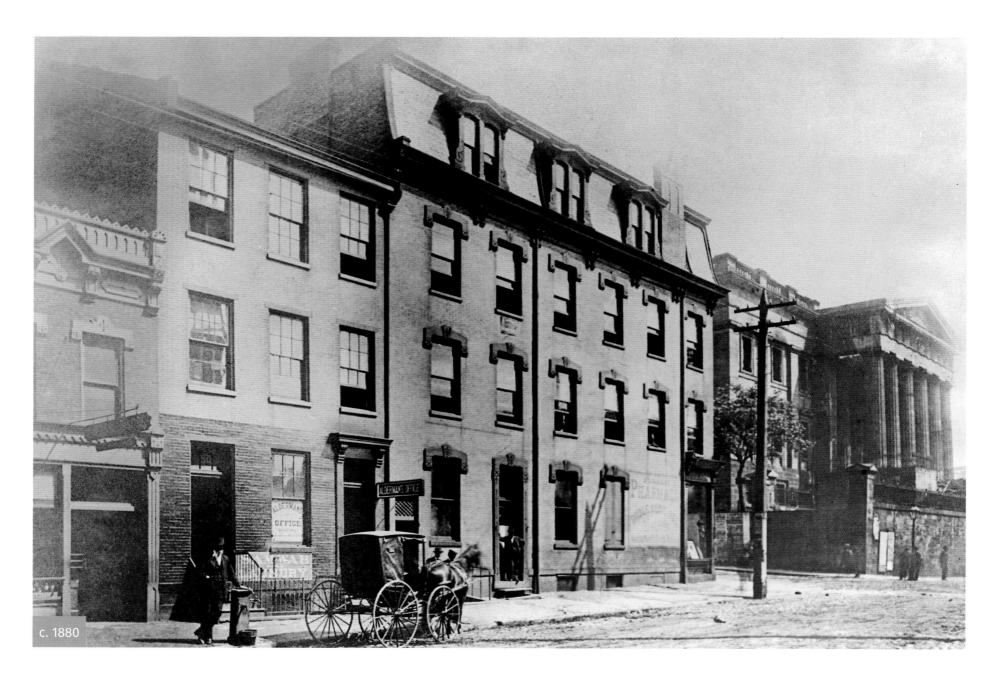

c. 1880

GRANT STREET / ALLEGHENY COUNTY COURTHOUSE
Standing on "the Hump" that was finally removed in 1913

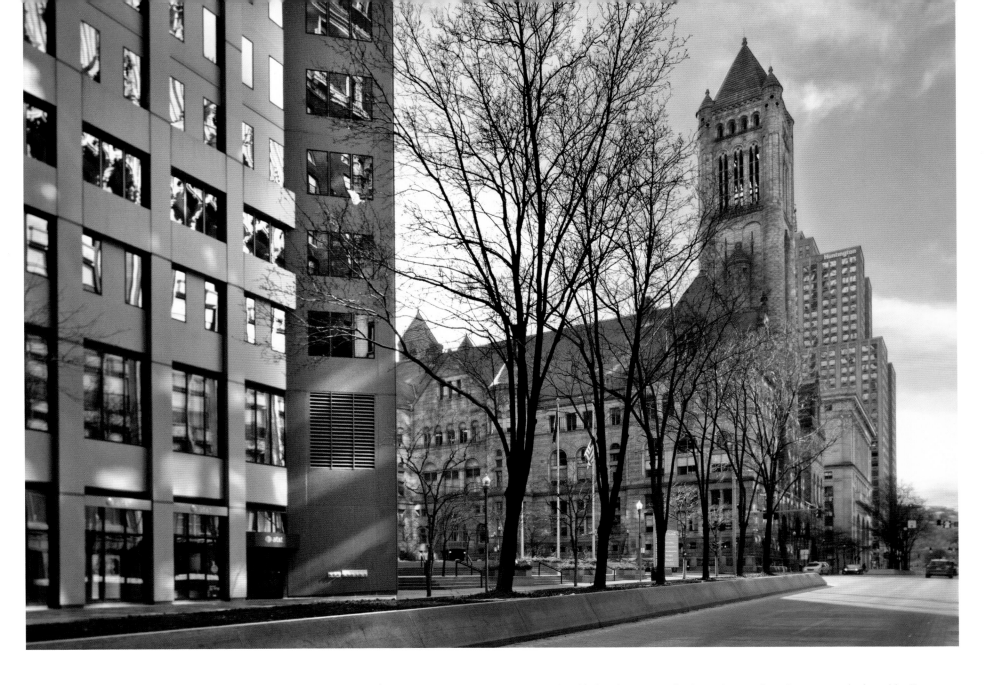

LEFT: The second Allegheny County Courthouse (at the extreme right) was a Greek Revival work of 1842 that burned in 1882. Here it is in its last days, seen from Grant Street, which has a small-town look. The courthouse stands noticeably above the street on a vestige of "the Hump," a natural rise of land that had been giving Pittsburghers trouble with its steep gradients throughout the nineteenth century. The Hump was attacked in fitful campaigns between 1836 and 1913, when its nuisance was settled once and for all and the street grade was brought down to its current level. Modern development along Grant Street followed the final 1913 push.

ABOVE: The third and present Allegheny County Courthouse was designed by Beaux Arts-trained architect Henry Hobson Richardson of Brookline, Massachusetts, and completed in 1888. It is Richardson's most impressive surviving monument. At a time when American architects usually looked to Classical precedents, Richardson adapted eleventh-century Romanesque forms to create a powerful new style for America. The final lowering of the Hump by about fifteen feet altered the proportions of the fronts, a fact most noticeable at the doorways. The steel-and-glass skyscraper in the foreground, now BNY Mellon Center, was designed to allow a broadside view of the courthouse.

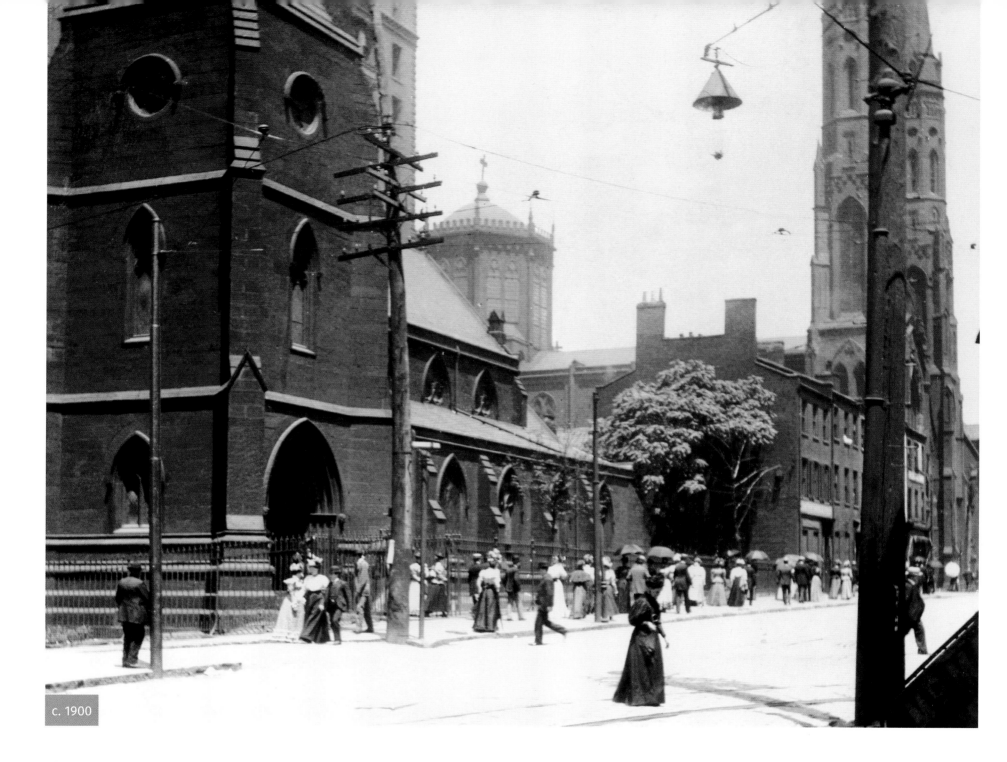

GRANT STREET

Today it is Pittsburgh's grand civic boulevard

FAR LEFT: Looking westward on Fifth Avenue from a point west of Grant Street around 1910. In the left foreground is Longfellow, Alden & Harlow's Carnegie Building of 1895, with a portion of the Kaufmann department store beyond that, which would be replaced in 1913. To the right is Cherry Way, with the once-famous Hotel Henry part way down the street. The old Mellon Bank and the much taller Park Building, designed around 1896 by George B. Post of New York, stand on the right side of the avenue at the corner of Smithfield Street. Highest on the skyline is Alden & Harlow's Farmers Deposit National Bank Building of 1902, with its remarkable terra-cotta cheneau.

RIGHT: Of the prominent buildings shown around 1910 only the Park Building remains, and it has suffered from extensive remodeling. Cherry Way still exists; there are no alleys in the city, just "Ways". The Carnegie Building was demolished in 1952, to make way for an expansion of the former Kaufmann's department store building. Plans in 2016 called for converting the former department store buildings into a hotel, apartments, and retail space. Across Fifth Avenue, at right, is the 1951 U.S. Steel Building (now 525 William Penn Place), and the granite-fronted PNC Financial Services Group call center, formerly Mellon Bank's "Temple of Finance" that was completed in 1924; the magnificent banking interior was destroyed in a 1999 remodeling for a short-lived Lord & Taylor department store. One PNC Plaza, completed in 1972, is the tallest building at the far end of Fifth Avenue. Highmark is the main tenant of Fifth Avenue Place, located at the terminus of Fifth and Liberty avenues.

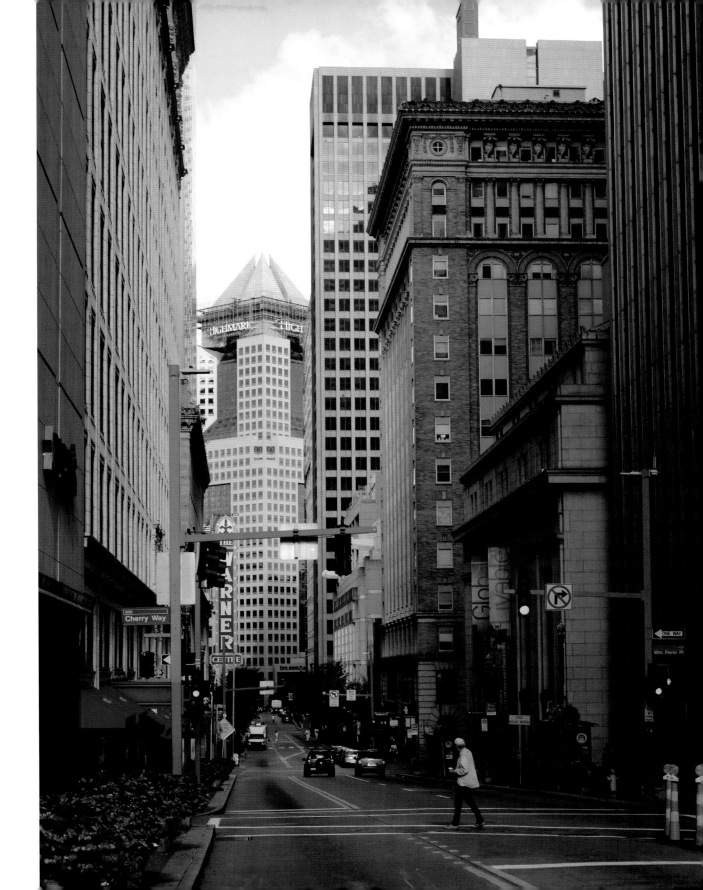

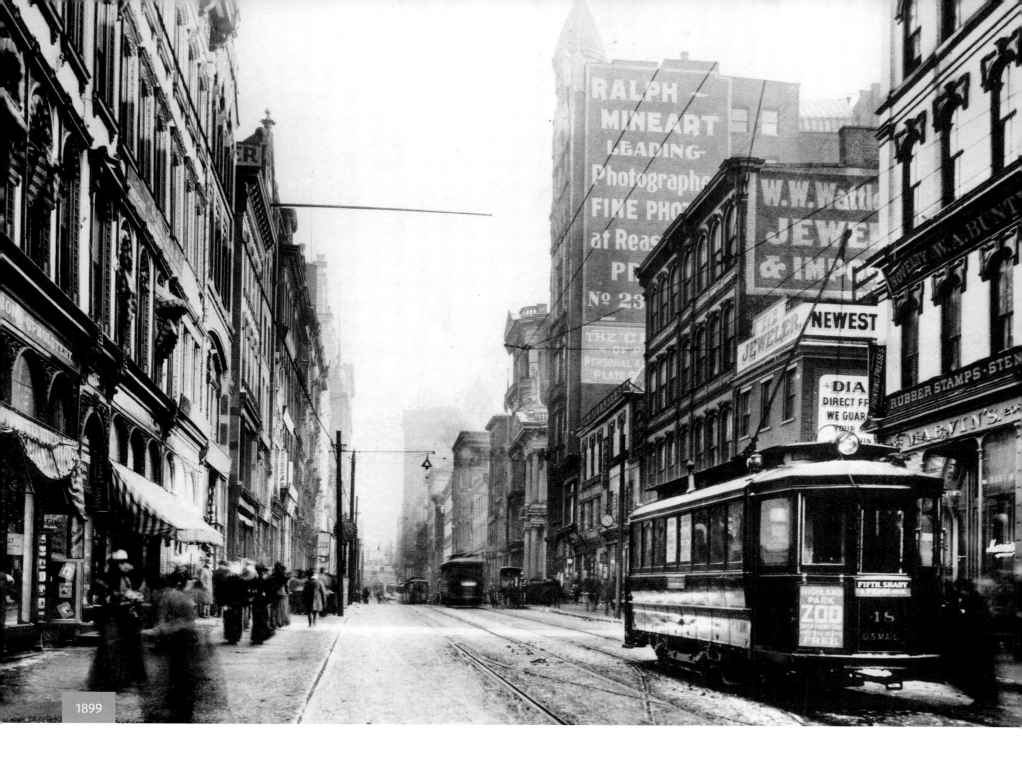

1899

FIFTH AVENUE

A historic commercial corridor where retail thrives today

46

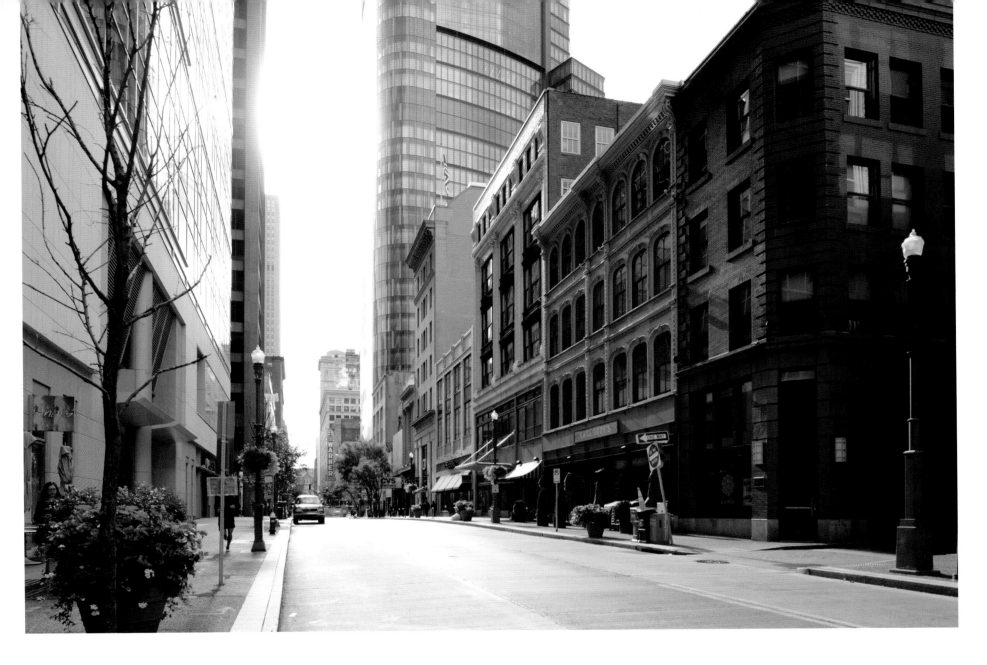

LEFT: Fifth Avenue looking east from Market Street in 1899, with a typical Victorian mixture of Italianate and indeterminate architectural styles, including a little Gothic, executed mainly in brick and cast iron. This scene would have seemed a little old-fashioned to the 1899 viewer, except for the presence of trolley cars. Before 1896, Fifth Avenue had cable cars that ran between the Triangle and East Liberty, but most of these buildings, in fact, are contemporary with the horsecars that preceded cable cars. In the distance a little of the Hump is visible, awaiting its final reduction.

ABOVE: In twenty-first-century Pittsburgh, the restoration and reuse of historic buildings is combined with new construction to create a distinctive, vibrant downtown. Three PNC Plaza (left) and the vertical edge of One PNC are across from The Tower at PNC Plaza at Fifth Avenue and Wood Street. Across from the Tower, an entire block of historic buildings has been saved and renovated. Millcraft Investments, a western Pennsylvania real estate developer, renovated a group of historic buildings in 2006–09 (from the tall tan building with the American flag to the red-brick corner building) to create Market Square Place, with forty-six loft apartments, a YMCA, retail, and underground parking.

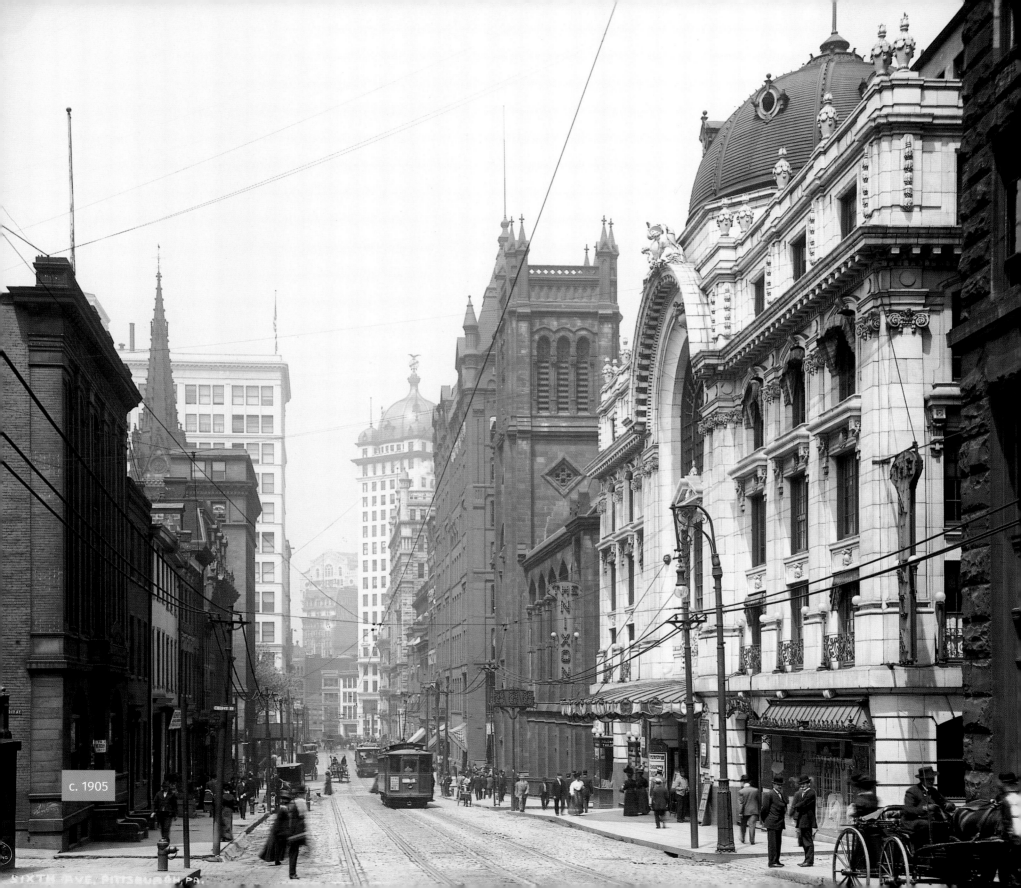

c. 1905

SIXTH AVE, PITTSBURGH, PA.

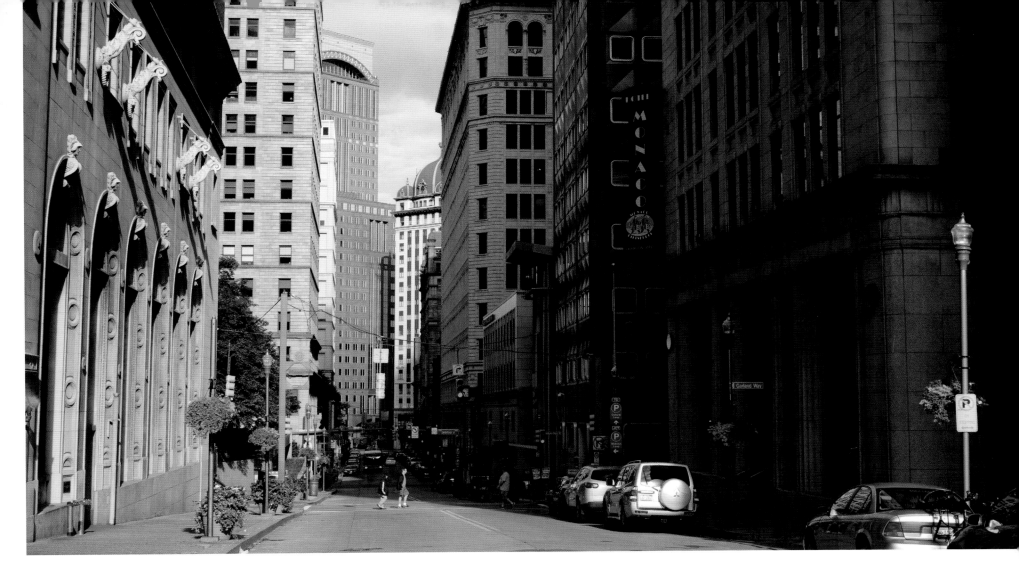

SIXTH AVENUE

The exemplary 1903 Nixon Theatre was replaced by the world's first aluminum-clad skyscraper

LEFT: Sixth Avenue facing west from Cherry Way looked like this around 1905. The two most prominent buildings on the right are the Nixon Theatre, built in 1903 and regarded as exemplary, and beyond that the German Evangelical Lutheran Church. Beyond the church is the Lewis Block, an office building; further back and discernible by its awnings is the brownstone-fronted Duquesne Club, designed in 1887 by Longfellow, Alden & Harlow. The Richardson Romanesque German National Bank of 1890 and the Keenan Building are seen in the distance. Across the street, the Gothic spire of the 1872 Trinity Church contrasts with the business architecture, and D. H. Burnham & Co.'s McCreery's department store rises beyond.

ABOVE: This mix of new and old—and of new uses in historic buildings—is refreshing. The Omni William Penn Hotel (left; opened in 1916, expanded in 1929), serves its original purpose. Hotel Monaco occupies a former office building from the early 1900s. Adjacent to it (and where the Nixon Theatre was) is the former Alcoa Building, designed in 1950–52 by Harrison & Abramovitz as the world's first aluminum-clad skyscraper. This was a proud work of the Pittsburgh Renaissance, along with the 1955 opening of Mellon Square (note the trees), with a roof-top garden, underground parking, and street-level retail. The former Alcoa Building has been converted into apartments. The terra-cotta building of 1913 that replaced the Lewis Block was designed as a department store, but now houses offices and street-level retail.

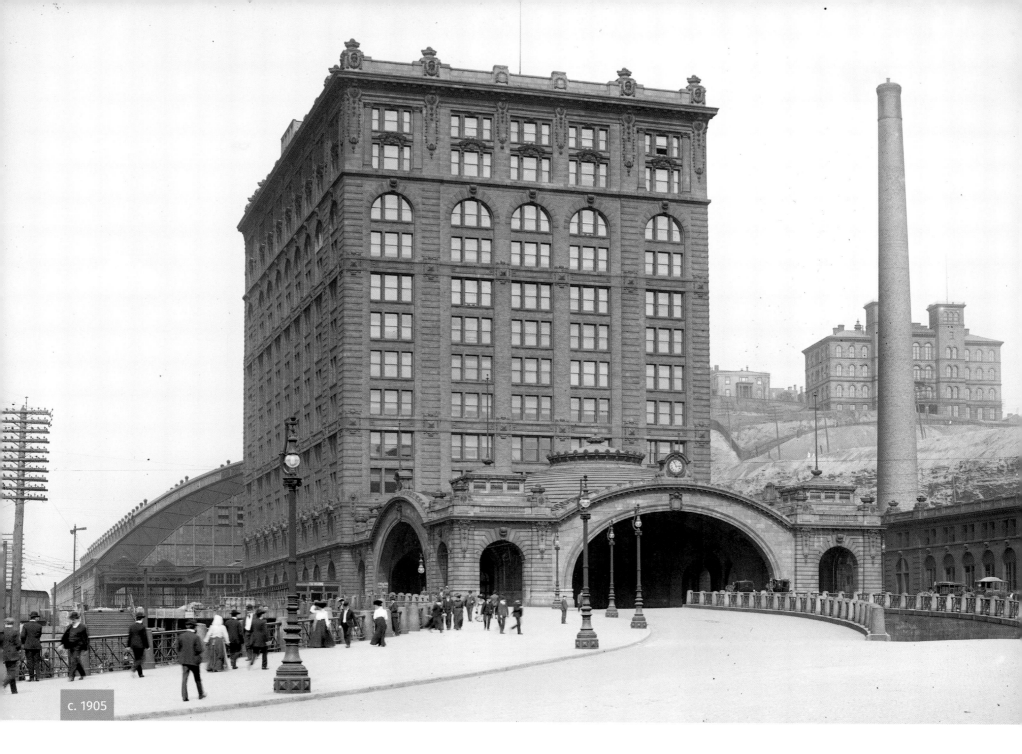

c. 1905

UNION STATION / THE PENNSYLVANIAN
Still bearing evidence of the city's "Pittsburg" spelling

LEFT: Henry Phipps' architect for his speculative buildings along the Allegheny River was Grosvenor Atterbury, a New Yorker. The Fulton Building to the left (partly obscured by the bridge) and the pendant Bessemer Building were similar in appearance but not in detail. The tile hipped roofs give a slightly Latin flavor to both designs but the Fulton Building's detail is inclined toward Classicism and the Bessemer has technological allusions, with detailing of steel strapwork and riveting. The bridge is the third Sixth Street Bridge, built in 1892. Replaced in the 1920s, it was floated down the Ohio to a second existence between Neville Island and Coraopolis; it lasted there until 1994.

RIGHT: Pressure from the U.S. secretary of war to increase Allegheny River bridge clearances led to the county's determination to rebuild the Sixth, Seventh, and Ninth Street bridges over the Allegheny River. The Pittsburgh Art Commission had some say in the appearance of public structures and, in this instance, chose the suspension bridge as a type to follow. Site conditions forbade conventional suspension bridges, though, and a novel German design was followed in these bridges, "The Three Sisters," whose principal structures are about 880 feet long. The Sixth Street Bridge was renamed the Roberto Clemente Bridge in honor of the Pirates' famous right fielder and is dramatically lit at night. The bridge connects the PNC Park baseball stadium on the North Shore with the Golden Triangle. The 12-foot bronze statue of Clemente (right) was designed in 1994 by Pittsburgh sculptor Susan Wagner.

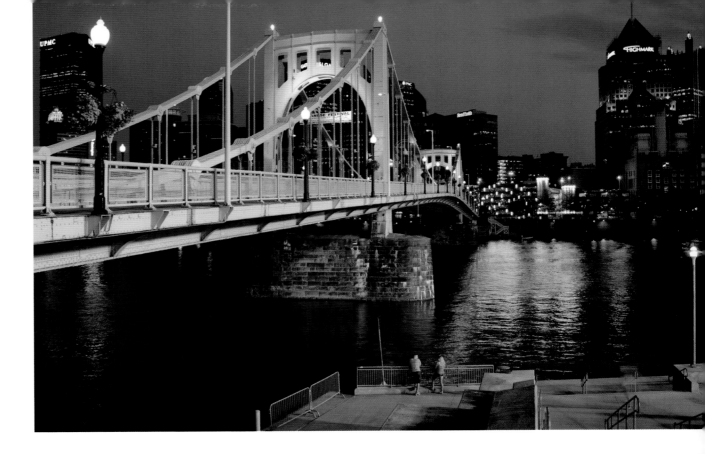

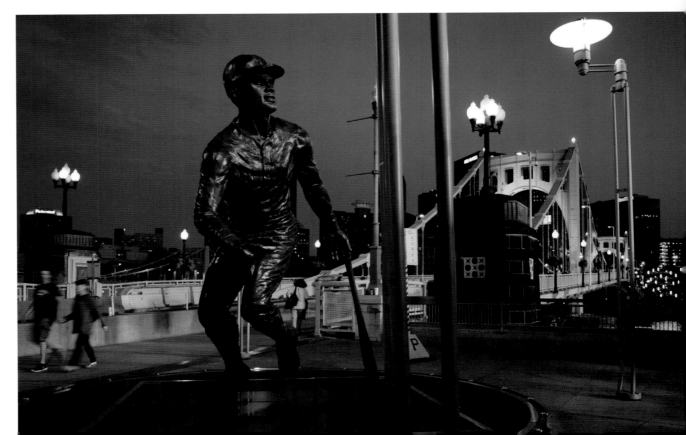

ALLEGHENY RIVER

A view still accessible from the Three Rivers Heritage Trail

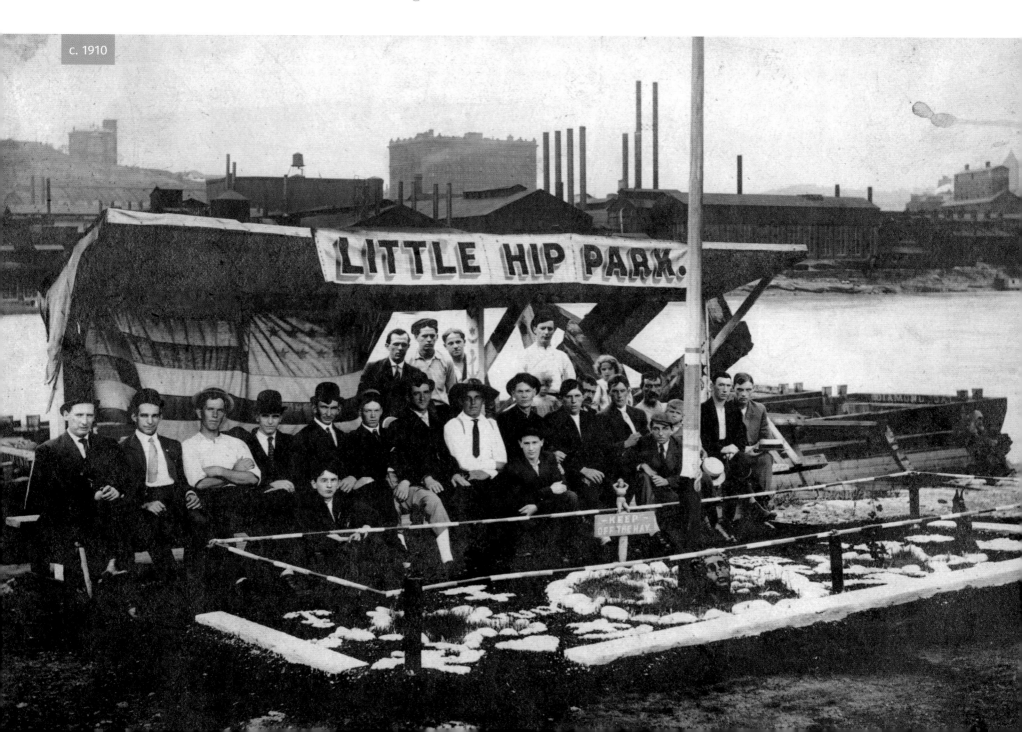

c. 1910

LEFT: Little Hip Park seems to have been a project of the working-class residents of a North Side neighborhood. Its executants, along with a small girl, are posed here in as formal a manner as they would ever have assumed. Across the Allegheny River is the Triangle, with Union Station and the old Central High School on the skyline and the Fort Pitt Foundry and the Wayne Iron and Steel Works beside the river. The sign reads "Keep Off The Hay."

BELOW: Little Hip Park lasted only a short time, but this view is still accessible from the Three Rivers Heritage Trail along the Allegheny River. Industry has vanished. The convention center, just beyond the Fort Wayne Railroad Bridge, catches the eye most readily: the greater part of its area hangs from fifteen masts, and its lightness of appearance is in marked contrast with the geometric solidity of the corporate office buildings that rise beyond (from left to right) for Federated Investors, UPMC/U.S. Steel, various tenants in the former Gulf Building, Koppers, Inc., and BNY Mellon.

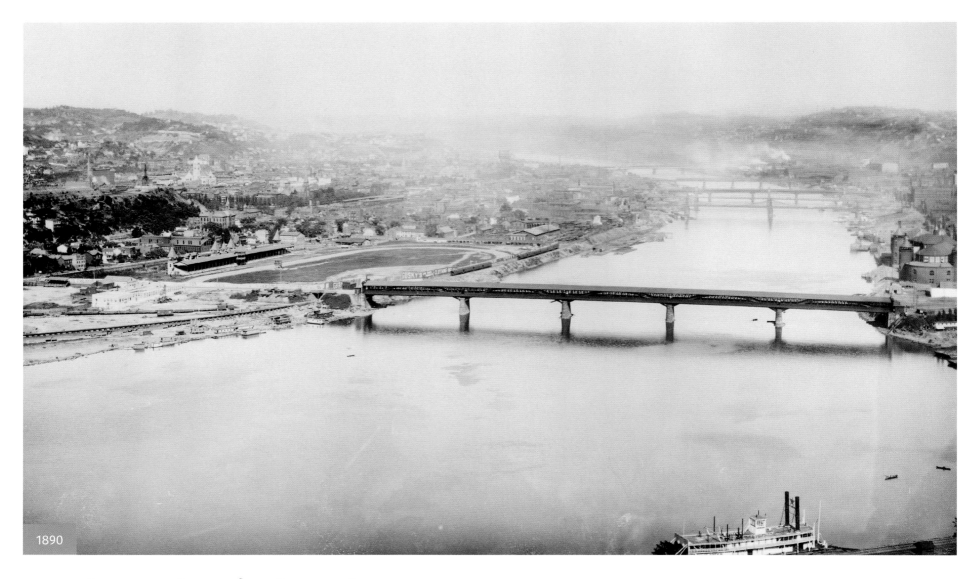

1890

ALLEGHENY CITY / NORTH SIDE
From a time when Allegheny was its own city

ABOVE: Until December 1907 the Allegheny River separated two distinct incorporated cities: Pittsburgh to the south, Allegheny to the north. In this view of 1890, Allegheny City is to the left. The Union Bridge, a wooden covered bridge of 1874, joins the two at the mouth of the Allegheny River. Its approach passes Exposition Park, long a sports field for both cities and where baseball's first modern World Series was played, matching the Boston Americans (who prevailed) against the Pittsburgh Pirates in 1903. Up the river we see the Sixth, Seventh, and Ninth Street bridges as well as the Pennsylvania Railroad's Fort Wayne Bridge, all to be replaced. In the center of Allegheny City, bright in its just-set granite, is the Carnegie Library that marks its crossroads.

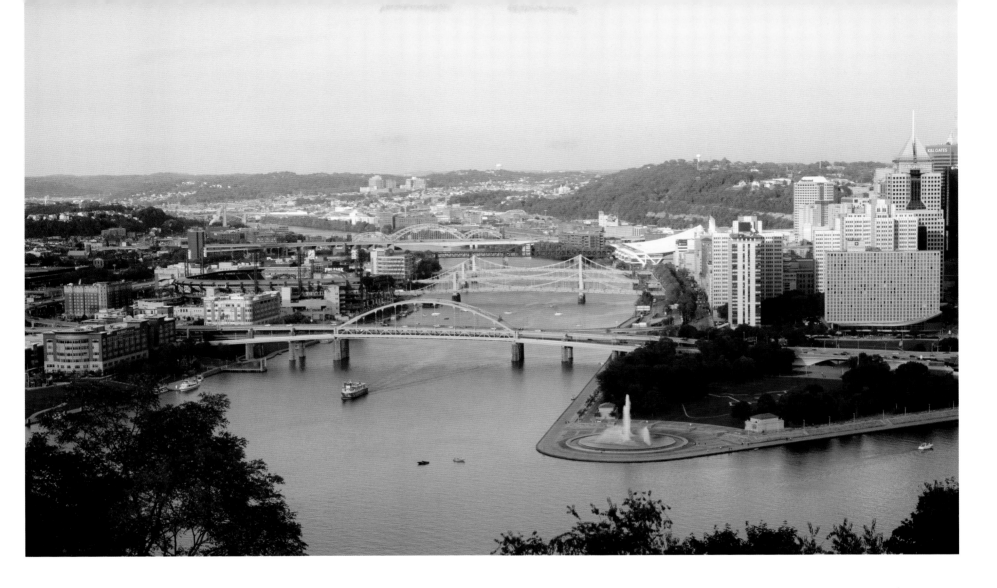

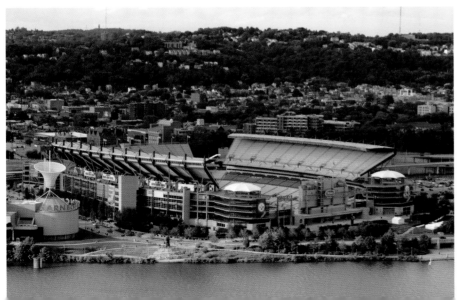

LEFT AND ABOVE: Heinz Field, home of the Pittsburgh Steelers (see below left) is located near the site of Exposition Park. It is the successor to Three Rivers Stadium, built for the Steelers and the Pittsburgh Pirates in 1970 and imploded in 2001. Today, the three rivers are cleaner and the hills are covered with trees. Office buildings are located near where Exposition Park once was on the North Shore, along with PNC Park, designed by HOK Sport in 2001, for the Pittsburgh Pirates. All the bridges in the 1890 photo have been replaced. The Fort Duquesne Bridge, recalling the name of the French fort that occupied the Point from 1754 to 1758, was completed in 1969. (In the 1960s it was the "Bridge to Nowhere," because one end was left hanging in midair until a site for the north-shore connecting ramps was selected.) Upstream from the Point, with its signature fountain, the Allegheny River bends past Pittsburgh's Strip District and Lawrenceville neighborhoods. The massive building complex in the distance is Children's Hospital of Pittsburgh of UPMC.

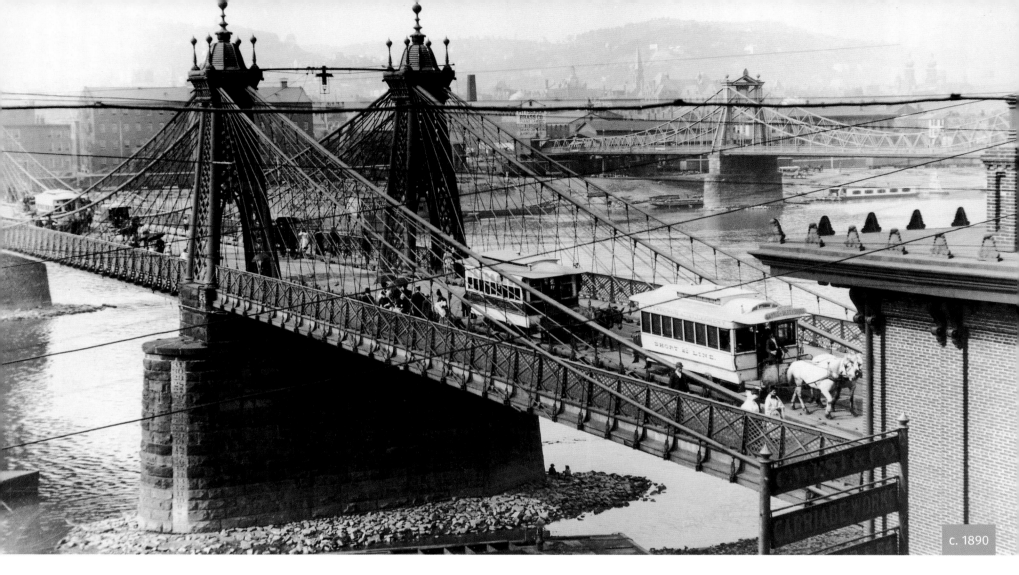

c. 1890

ALLEGHENY RIVER BRIDGES

Named for Roberto Clemente, Andy Warhol, and Rachel Carson

ABOVE: Until 1896 all Pittsburgh river bridges were privately erected and charged tolls. Here are two Allegheny River suspension bridges, photographed around 1890. In the foreground is the second Sixth Street Bridge, built in 1859, which lasted until 1891. Its engineer was John Augustus Roebling, who already had the local aqueduct for the Pennsylvania Canal and the second Smithfield Street Bridge to his credit. He would go on to design the Brooklyn Bridge. Beyond is the Seventh Street Bridge of 1884, designed by Gustav Lindenthal, who had already seen erected the third (and present) Smithfield Street Bridge.

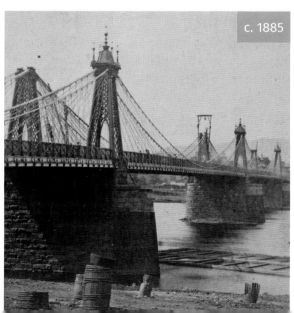

c. 1885

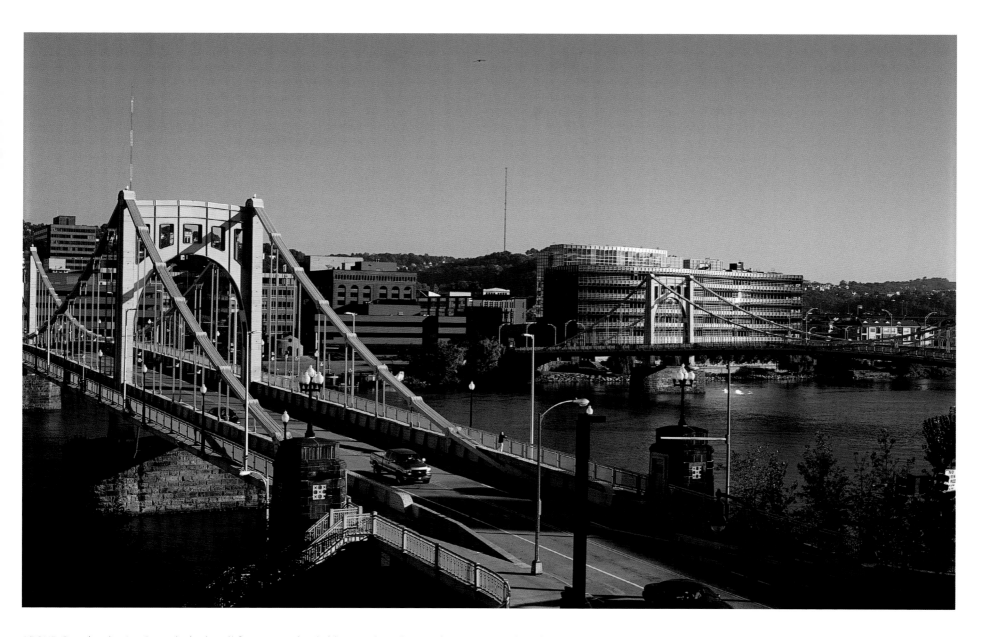

ABOVE: Despite the Art Commission's call for suspension bridges under adverse site conditions and the odd erection procedures this required—they had to be framed as cantilevers, then transformed into "self-anchored" suspension bridges when the basic structures were completed—the Three Sisters have always been favorites, and one received a beauty prize from the American Institute of Steel Construction on its completion in 1928. The Three Sisters have been renamed to honor three people with Pittsburgh connections: baseball player Roberto Clemente, pop artist Andy Warhol, and environmentalist Rachel Carson. The Roberto Clemente Bridge is in the foreground. Just beyond the Andy Warhol (Seventh Street) Bridge is Alcoa's corporate office building of 1998, a dramatic glass and aluminum structure whose façade suggests the undulations of the Allegheny River. The Rachel Carson Bridge is just out of view to the right.

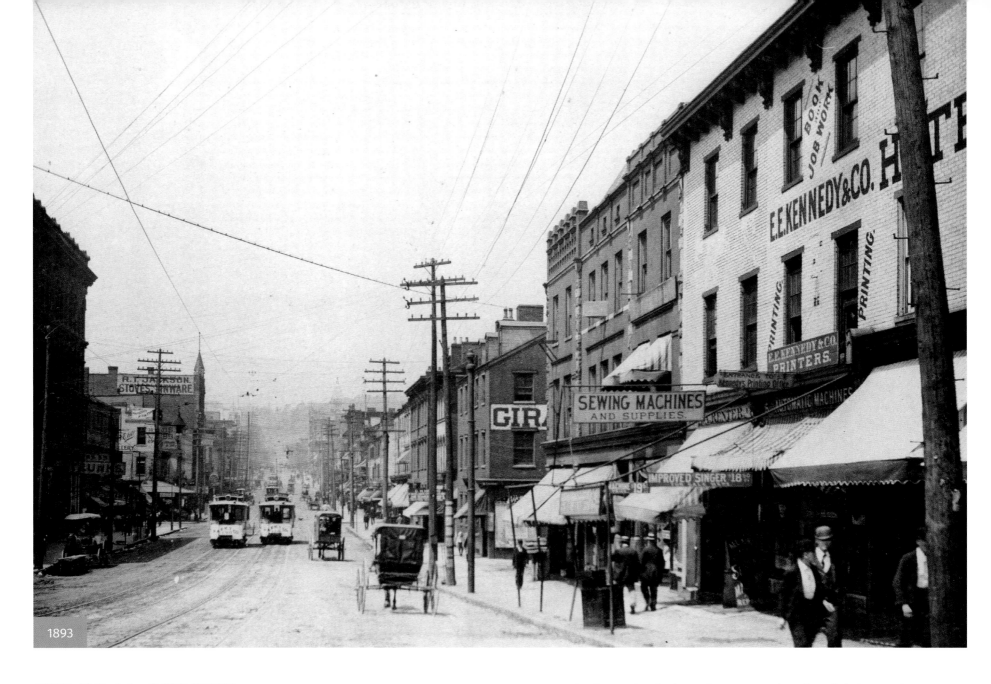

1893

FEDERAL STREET
The continuation of Sixth Street in Allegheny City

ABOVE: Federal Street in Allegheny City was a continuation of Sixth Street in Pittsburgh: a commercial main street without pretense. This was the view in 1893, with trolleys at its center, looking north. Federal Street lost much of its eminence in the 1960s, when it ceased to lead from the river to the old town crossroads. A pedestrian mall was built across the end of the old Allegheny Town, laid out in 1787 by David Redick, emphatically turning blank walls toward the Triangle and the North Shore. The old Fort Wayne Station that had added life and a touch of splendor to the street scene was demolished, leaving only the elevated rail line that had passed it.

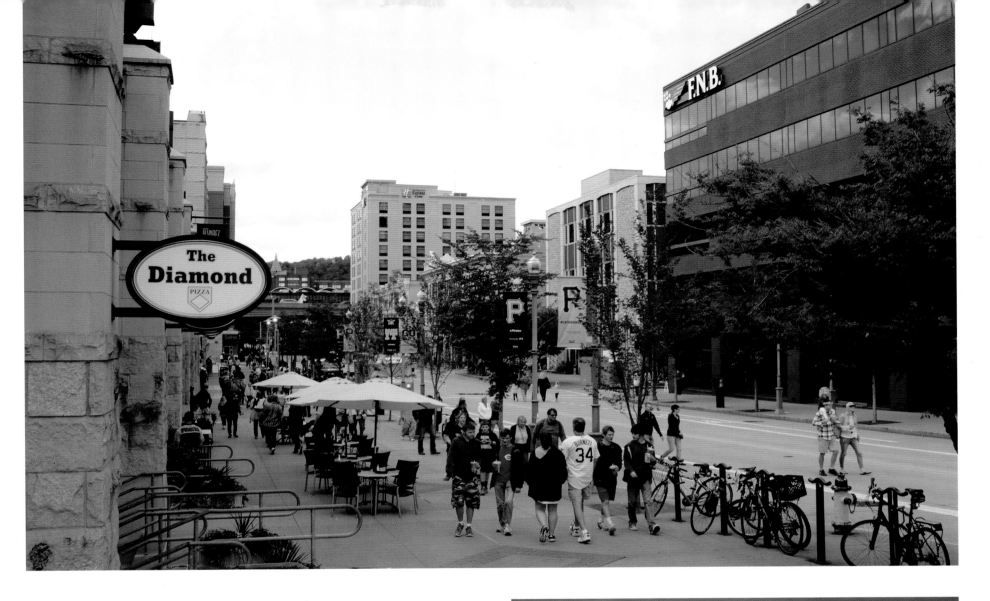

ABOVE: Opened in 2001, PNC Park (see inset) dominates the left-hand side of Federal Street and the area of the North Shore directly opposite the Golden Triangle. Statues of Willie Stargell, the Pirates' beloved left-fielder and first baseman, and Roberto Clemente enliven the space. Restaurants, stores, and parking garages fill new and old buildings across the street from the stadium. The Andy Warhol Museum, celebrating the work of the famous pop artist who was born in Pittsburgh, is located just east of Federal Street in a handsomely renovated building of 1911.

ALLEGHENY CENTER

The Carnegie Library building is awaiting a new use

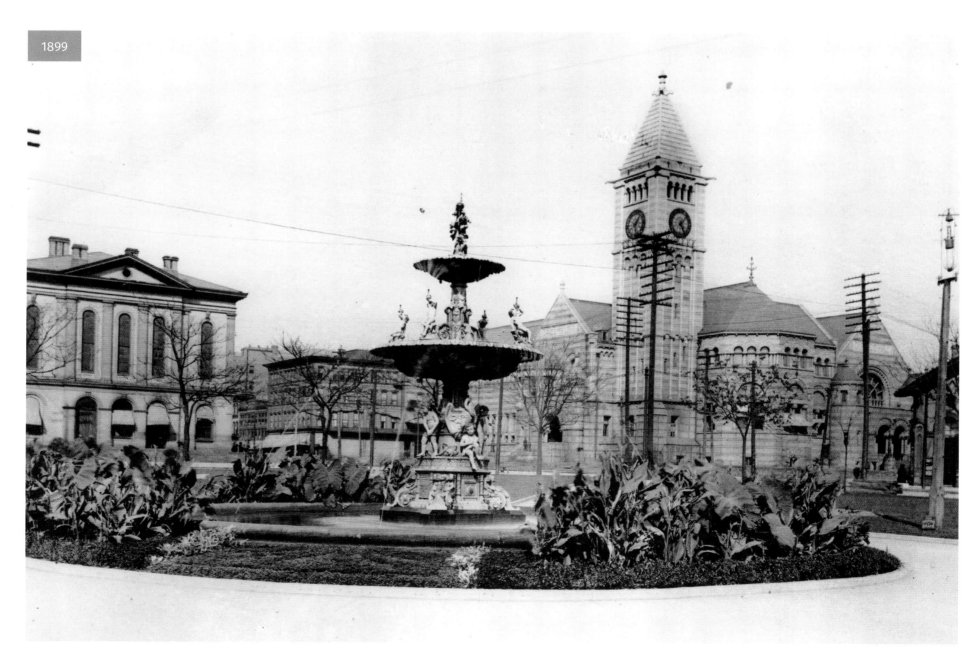

LEFT: This was the center of Allegheny City in 1899. A corner of the Market House (right) appears at the far right edge of the photo, but the place of honor goes to the Carnegie Library, the second that Andrew Carnegie commissioned in the United States (Braddock was the first). To the far left is the city hall of Allegheny. The fountain occupies a fourth quadrant of this public area of Allegheny Town's century-old crossroads.

BELOW: Old Allegheny was drastically altered during urban renewal in the 1960s. Neither Federal nor Ohio streets carries wheeled traffic to the center point anymore. Apartments occupy the site of the

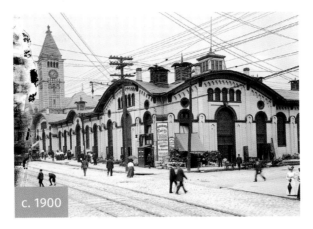

c. 1900

handsome old Market House. The city hall's site has long been taken by the Buhl Planetarium (hidden by the water vapor) and since converted to house part of the Children's Museum of Pittsburgh. The Victorian fountain went out of fashion—and existence— years ago, but a magical, interactive sculpture by environmental artist and sculptor Ned Kahn has taken its place. *Cloud Arbor*, commissioned by the Children's Museum, is a forest of 64 stainless steel poles with high-pressure fog nozzles that convert water into a cloud every few minutes. The former Carnegie Library building now houses the New Hazlett Theater and has more space available for other new uses.

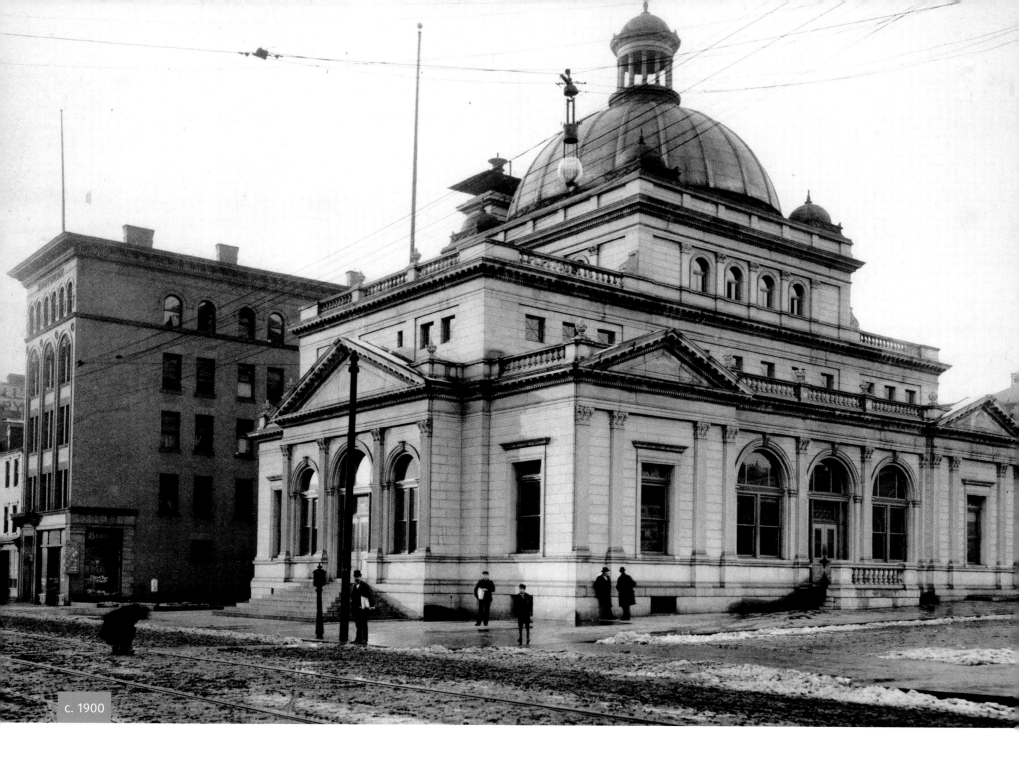

c. 1900

ALLEGHENY POST OFFICE / PITTSBURGH CHILDREN'S MUSEUM

A textbook example of preservation in the community

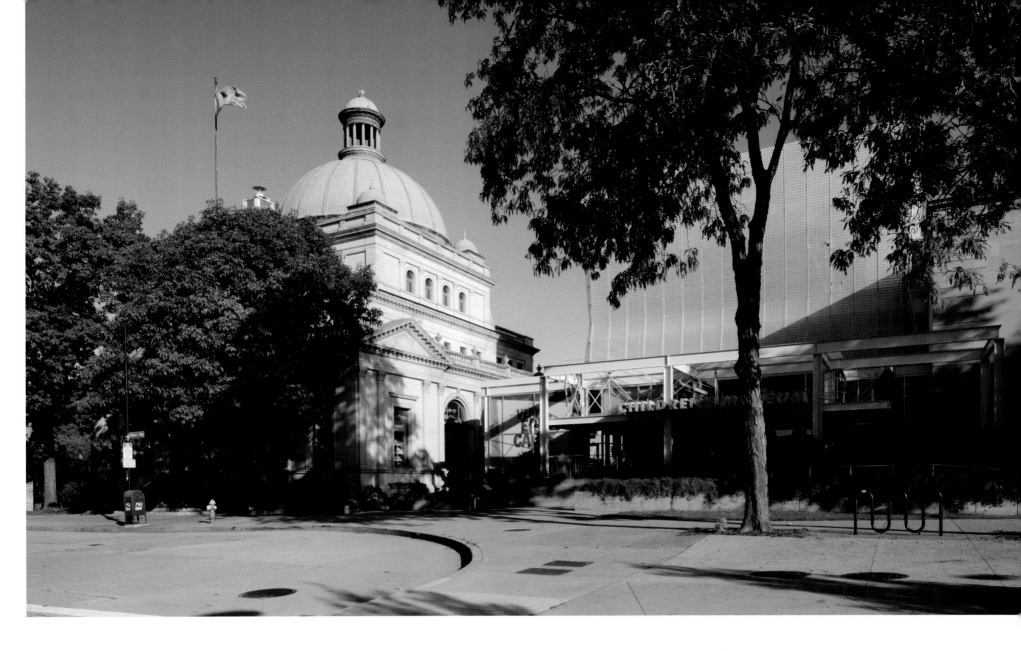

LEFT: Adjacent to the Allegheny City Hall on Ohio Street was this post office of 1897, the work of the U.S. Treasury architect William Martin Aiken. Its formality of character was kept within the human scale. The central interior beneath the dome was a full-height mail-sorting room, the customers being confined to surrounding corridors. The post office was slated for demolition as part of the urban renewal plans in the 1960s, but was saved by the Pittsburgh History & Landmarks Foundation, concerned citizens, and neighborhood organizations. In 1971 it became the headquarters and museum for the Pittsburgh History & Landmarks Foundation until its move to Station Square in 1985.

ABOVE: The Pittsburgh History & Landmarks Foundation handed the old post office over to the Pittsburgh Children's Museum as a gift in 1991. (The museum had been housed in the building since the 1980s.) With visitation increasing, the Children's Museum acquired the vacant Buhl Planetarium building of 1939 (far right) and commissioned Koning Eizenberg Architecture of Santa Monica, California, to design the 2004 expansion. A twenty-first-century "lantern" building was constructed to connect the nineteenth- and twentieth-century buildings. Ned Kahn designed a sculpture, *Articulated Cloud*, for the building façade: small polycarbonate tiles, hinged only at the top, ripple in the wind, thus making wind visible. At night, the sculpture is illuminated. The Children's Museum has won many prestigious awards for its innovative design.

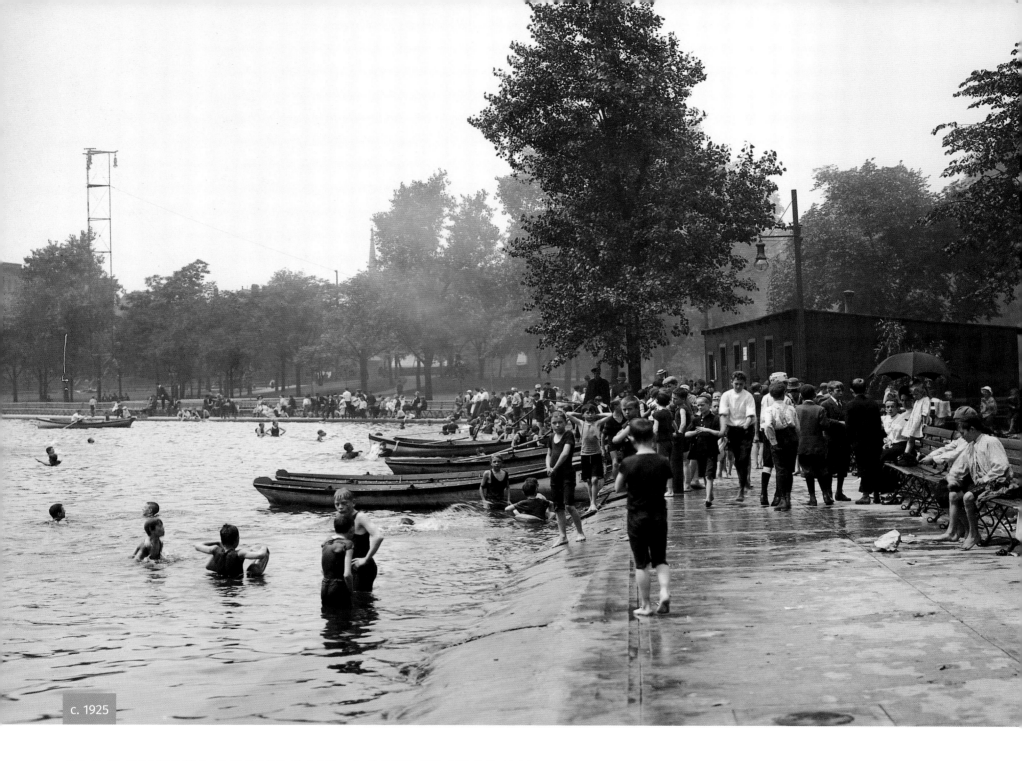

c. 1925

ALLEGHENY COMMONS, LAKE ELIZABETH

The grazing commons were turned into a Victorian Park in 1876

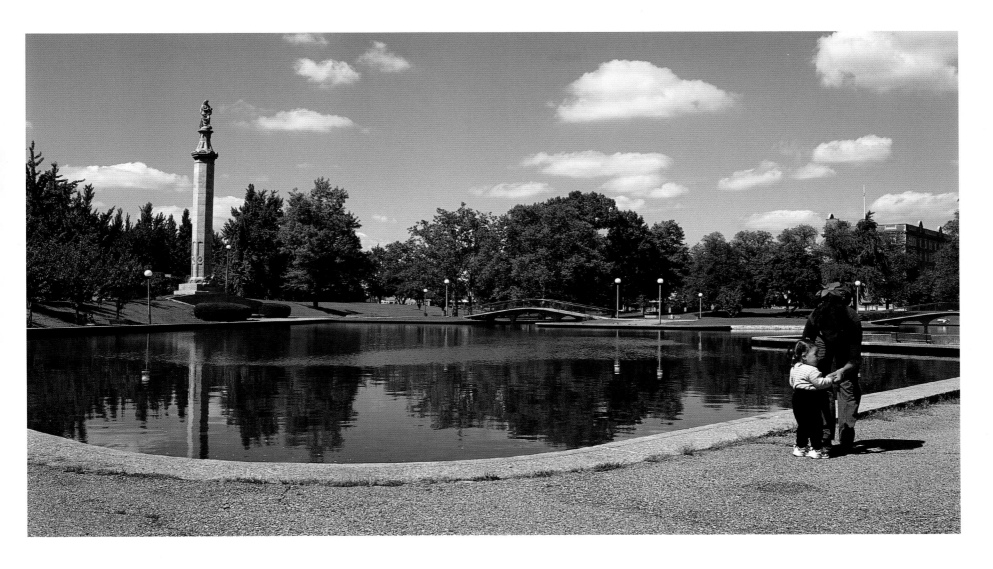

LEFT: The 1788 plan for Allegheny City called for a town a third of a mile on each side surrounded by grazing commons that were surrounded by "out-lots" for agriculture. In the late 1860s, with the out-lots built up, the city turned the Allegheny Commons into an elaborate mid-Victorian park. The New York firm of Mitchell, Grant & Co. designed the plan for Allegheny Commons, which was completed in 1876 and included lawns, monuments, fountains, tree-lined paths, and ornamental flower beds. West Park, the largest of its areas, eventually received a conservatory, a bandstand, a memorial to the dead of the warship *Maine*, and a romantic pond called Lake Elizabeth, seen here in the mid-1920s.

ABOVE: Although no longer a place for swimming, boating, or ice skating, Lake Elizabeth provides solace to many people. The lake was modernized in the 1960s, given a freeform shape and neatly edged. The Soldiers' Monument was designed by Louis Morganroth of Mitchell, Grant & Co. in 1871 with Peter Charles Reniers as sculptor. Originally erected on Monument Hill (further north), the monument was moved to the Allegheny Commons in 1931. A restoration plan has been prepared for Allegheny Commons by Pressley Associates, Inc. of Cambridge, Massachusetts. If funds can be raised, the boathouse will be rebuilt. The National Aviary is located in the commons, and the historic neighborhoods of Allegheny West, Manchester, Central North Side, the Mexican War Streets, and Deutschtown are within walking distance of the park.

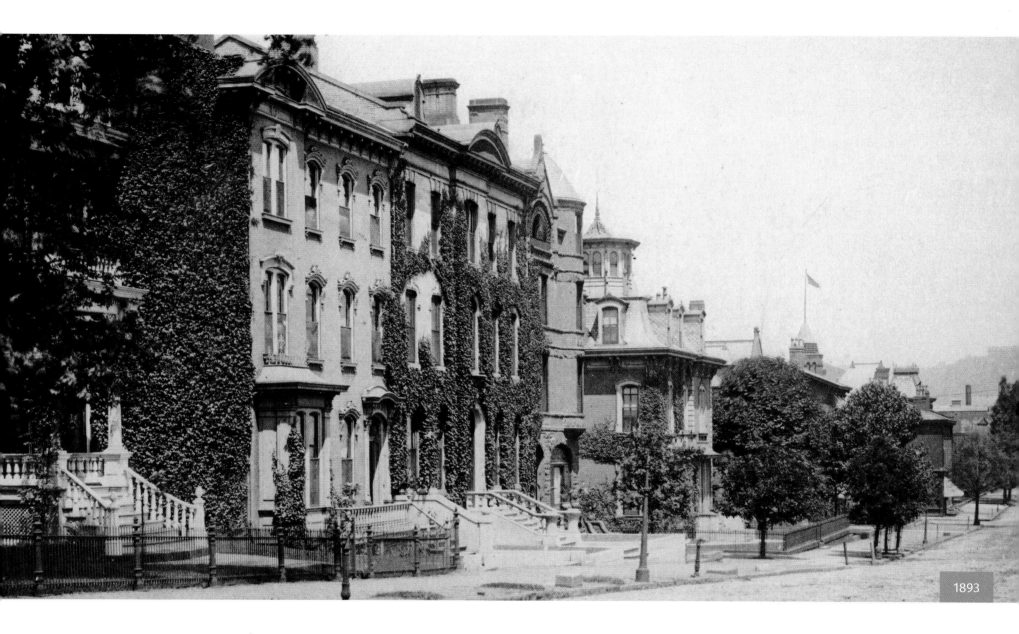

1893

IRWIN AVENUE / BRIGHTON ROAD
Once a showplace neighborhood

ABOVE: Irwin Avenue, seen here in 1893, was one of the showplaces of Allegheny City, fronting on West Park. It formed the eastern edge of Allegheny West, a neighborhood of solid prosperity, where, for instance, millionaires whose names spoke of iron and steel chose to live: Joneses and Laughlins, Snyders, Byerses, and Olivers. The mansard-roofed house with the cupola, for instance, is that of M. F. Laughlin.

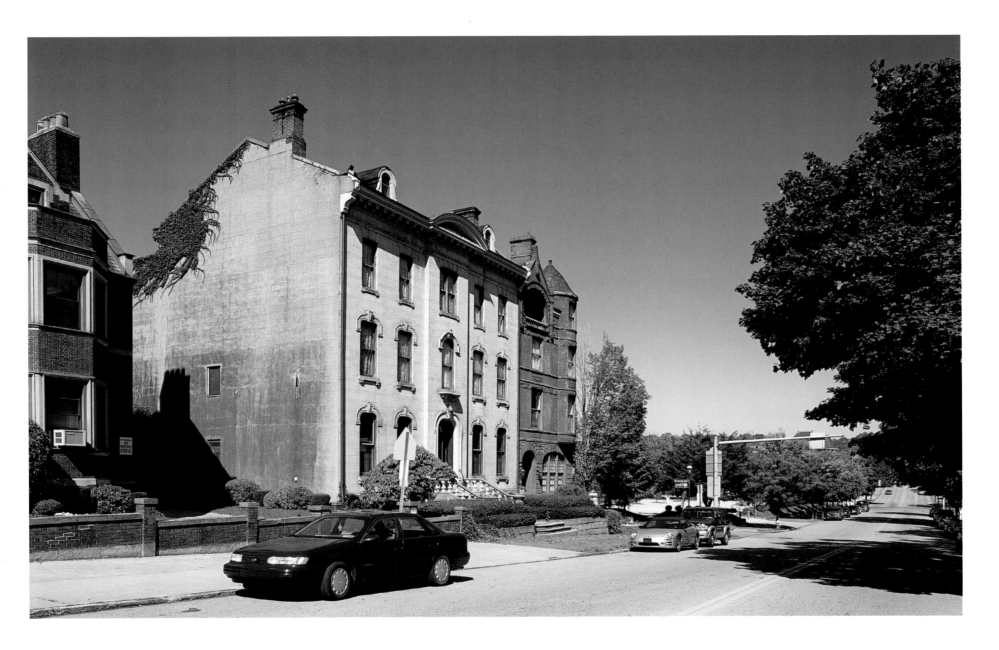

ABOVE: Irwin Avenue has been renamed Brighton Road. Several of its houses were demolished in the late 1950s. However, two have survived: the limestone house of c. 1871 of Letitia Holmes, widow of a pork packer, and the very narrow Romanesque Harry Darlington house of c. 1890. Both houses have been beautifully restored and are located in the Allegheny West City Historic District and National Register Historic District. Thanks to the efforts of many preservationists, Allegheny West has recovered much of its prominence. It has pleasant late-Victorian homes and two outstanding churches: Emmanuel Episcopal, designed by H. H. Richardson in 1885-86, and Calvary United Methodist, designed in 1893-95 and famous for three impressive windows designed by Tiffany Studios.

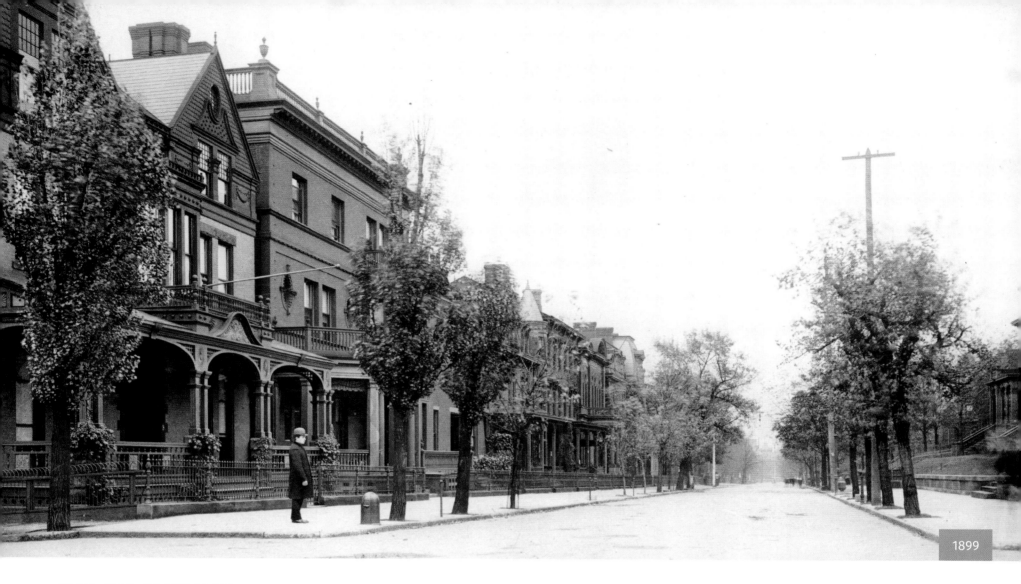

1899

RIDGE AVENUE

Where the captains of industry lived in the nineteenth century

ABOVE: Around the corner on Ridge Avenue the display continued. To the right, in this view of 1899, can be seen the rising ground of Monument Hill, which industrialists such as the Olivers and Scaifes shared with the Western Theological Seminary, an institution that had been in the neighborhood since 1827. The houses on the left, fairly new, were soon to be replaced by even larger houses and an isolated section of the Western Theological Seminary. In those prezoning days Ridge Avenue millionaires lived not far from the workplaces of the Clark Company, makers of chewing gum; some gas storage tanks of the Equitable Gas Company; the Damascus Bronze Company; and the Pittsburgh Iron Folding Bed Company.

RIGHT: The English-Oliver House at 845 Ridge Avenue. The land was originally part of the Denny and Dubarry estate, and was purchased in 1871 by Andrew H. English, bookseller and printer. The house was completed in 1874 and was occupied by English until acquired by Henry W. Oliver in 1879.

c. 1963

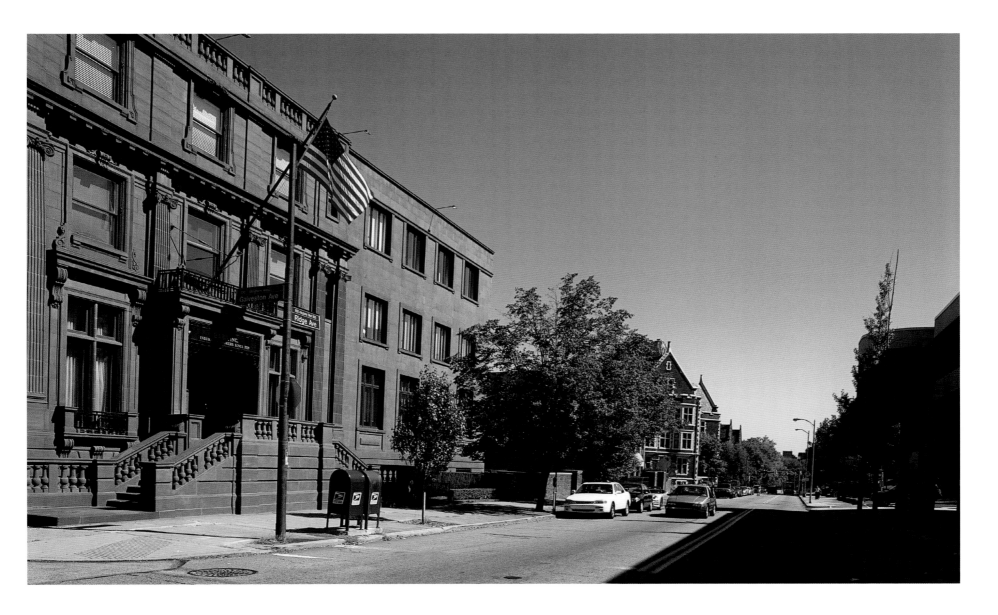

ABOVE: As the twentieth century began, the confidence in Ridge Avenue and its future seemed only to increase. The steelmaker Benjamin Franklin Jones Jr. and the ironmaker William Penn Snyder built within a block of each other. Here, the Snyder house of 1911 dominates the left side of the street. Converted years ago to business, it received the plain annex to the right. Further down the street is all that remains of the Western Theological Seminary built in white terra cotta and red brick. Beyond that is the great Jones house of 1908, now part of the Community College of Allegheny County. Across the street, beginning in the 1960s, the college was built anew for the most part.

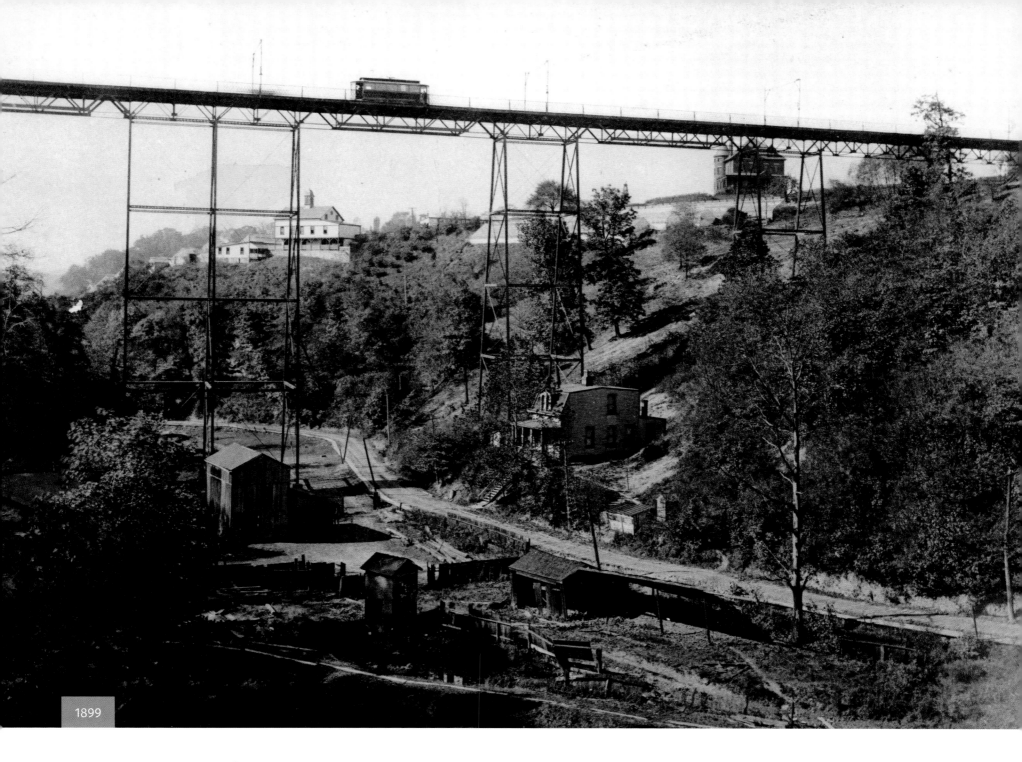

1899

HIGH BRIDGE / CALIFORNIA AVENUE BRIDGE
Riding trolleys to Bellevue was a giddy experience

76

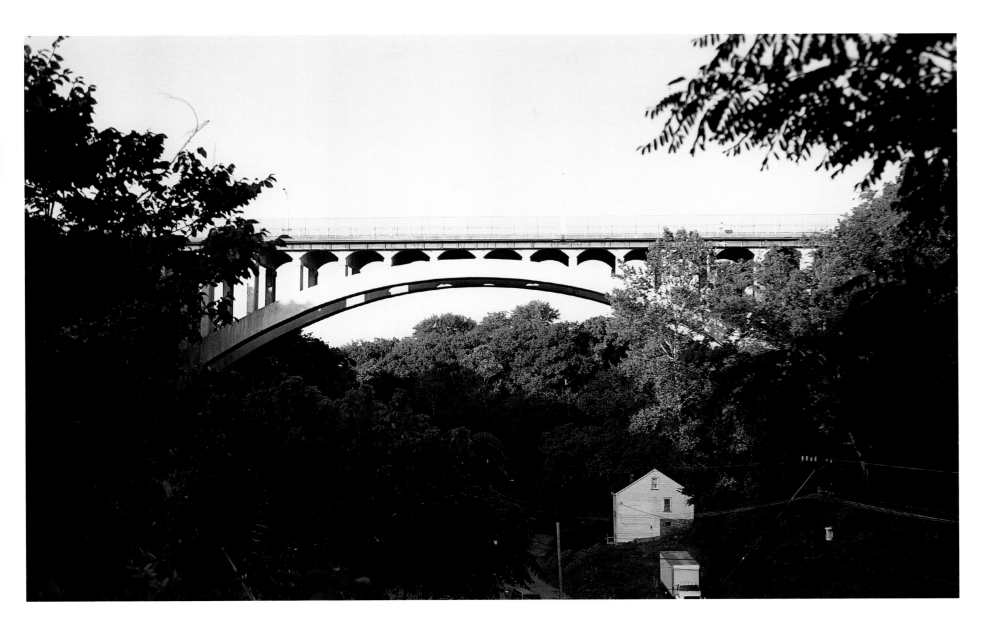

LEFT: The High Bridge, running between the western edge of Allegheny City and the Ohio River suburb of Bellevue, was already up and carrying trolleys in 1893. This view of 1899 shows what a giddy experience this manner of leaving town could offer. The Ohio River towns, at river level, had benefited from commuter rail traffic as early as 1851, but development on the rising ground depended on the trolley.

ABOVE: A highway bridge built in the 1920s now carries California Avenue in Pittsburgh to join Lincoln Avenue in Bellevue. At one time it carried the trolleys as well, which went on to a loop in Emsworth, six miles down the Ohio River. The new bridge reflected a change in technology and design attitudes. It was built of reinforced concrete, a glamour material of the early twentieth century, and it showed a new interest in making bridges objects of beauty.

MONONGAHELA WHARF, MOUNT WASHINGTON

Today the leisure boat traffic is on the other side of the Monongahela

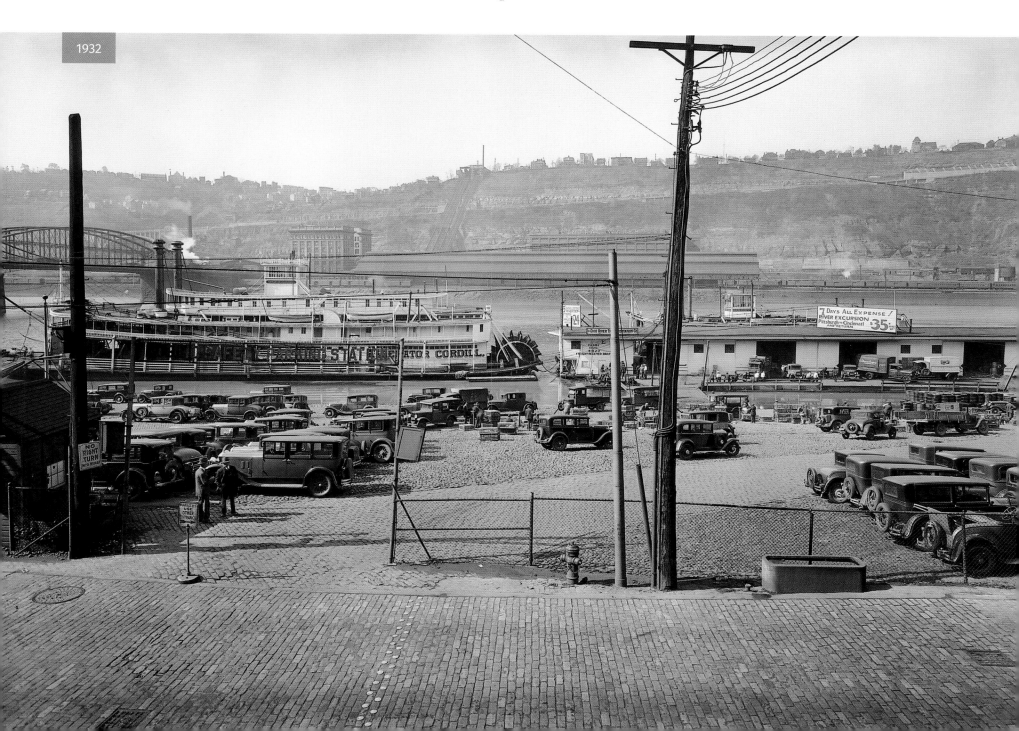

1932

LEFT: Mount Washington is remembered as the vantage point, 400 feet above the Monongahela River, from which the Virginia major of that name spied out the strategic possibilities of the forks of the Ohio River. Here is a view of Mount Washington in 1932 from the Monongahela Wharf, which is seen as half transshipment place, half parking lot. The passenger boat *Senator Cordill* and the very low excursion fare advertised on the wharfboat give a period flavor to the scene. The double tracks of the Monongahela Incline, carrying passengers up and down Mount Washington since 1870 and freight since 1884, cross over the Mount Washington Roadway, opened in the late 1920s and rising up the hillside.

BELOW: The Pittsburgh & Lake Erie Railroad ceased most passenger operations in the 1960s, and indeed its freight operations at the Pittsburgh station were in a sharp decline by then. A terminal-sized railroad station was thus approaching uselessness, though the main line that passed it remained busy. The Pittsburgh History & Landmarks Foundation proposed adaptation of five of the surviving railroad structures for new commercial purposes, was given its opportunity in 1976, and served as prime developer of the fifty-two-acre mixed-use site that has prospered as Station Square. Privately owned since 1994, new buildings and public spaces have been added in front of the red-brick Commerce Court. Pleasure boats dock at a new marina, anchored to a stair-and-elevator tower that connects to a pedestrian bridge over the busy railroad tracks.

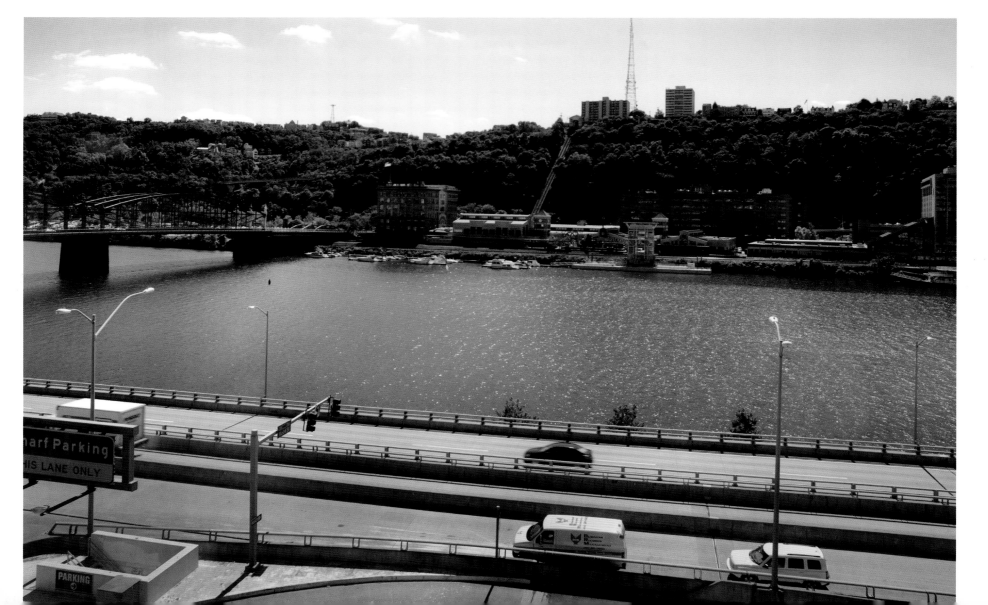

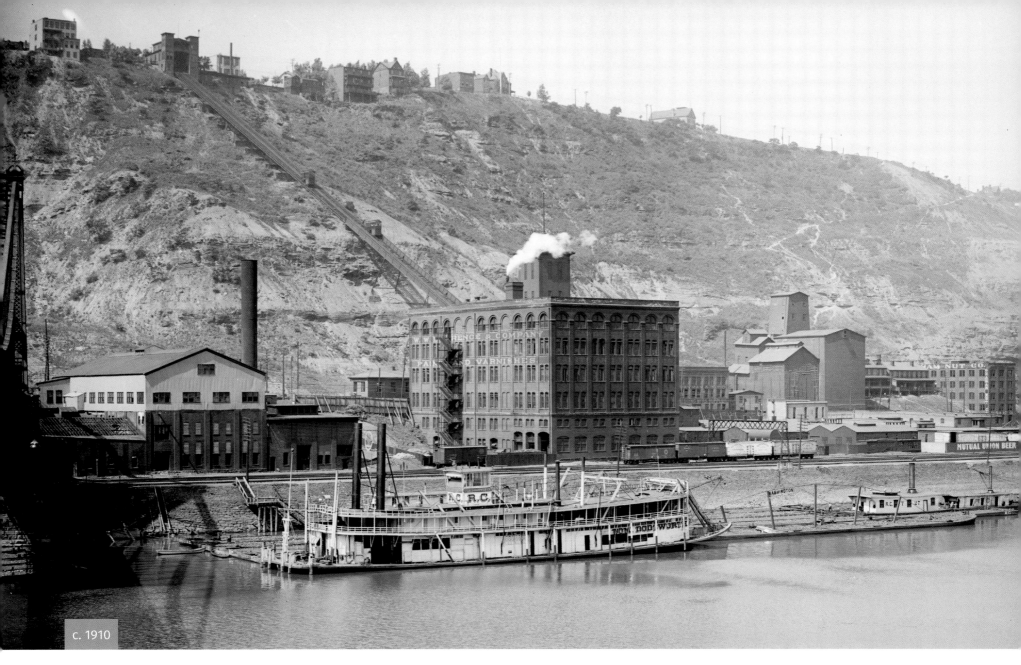

c. 1910

DUQUESNE INCLINE, MOUNT WASHINGTON

One of two surviving inclines

ABOVE AND RIGHT: Inclined planes were already in use in the Pittsburgh area in the mid-nineteenth century, but the earliest ones carried coal down from Mount Washington. In 1870 the Monongahela Incline, also on Mount Washington, initiated local passenger service and in 1877 the Duquesne Incline, shown here, began operations a mile to the west. Other inclines soon followed, and at one time there were nearly twenty inclines in and near Pittsburgh, but one by one they yielded to the automobile and now only two are left: the Monongahela and the Duquesne. Both began steam-powered but converted to electricity long ago. The Duquesne Incline machinery room is well worth seeing, with its original cast-iron cable drum and drive gear with 130 removable wooden teeth.

RIGHT: St. John's, with its Eastern-looking domes, is used in pictures sometimes to symbolize the polyethnic character of the South Side, or of Pittsburgh as a whole. The area's first settlers were of English, Scottish, Irish, and German descent, but the expansion of industry in the latter half of the nineteenth century drew upon people from all of Europe, especially Slavs and Magyars. The parishioners of St. John's still make pierogi in the church basement and sell them to Pittsburgh businesses, taverns, and families. The Tenth Street Bridge of 1931, the city's only conventional suspension bridge, is visible in both photographs. Duquesne University dominates the Bluff, and the vertical white siding of UPMC Mercy is just visible.

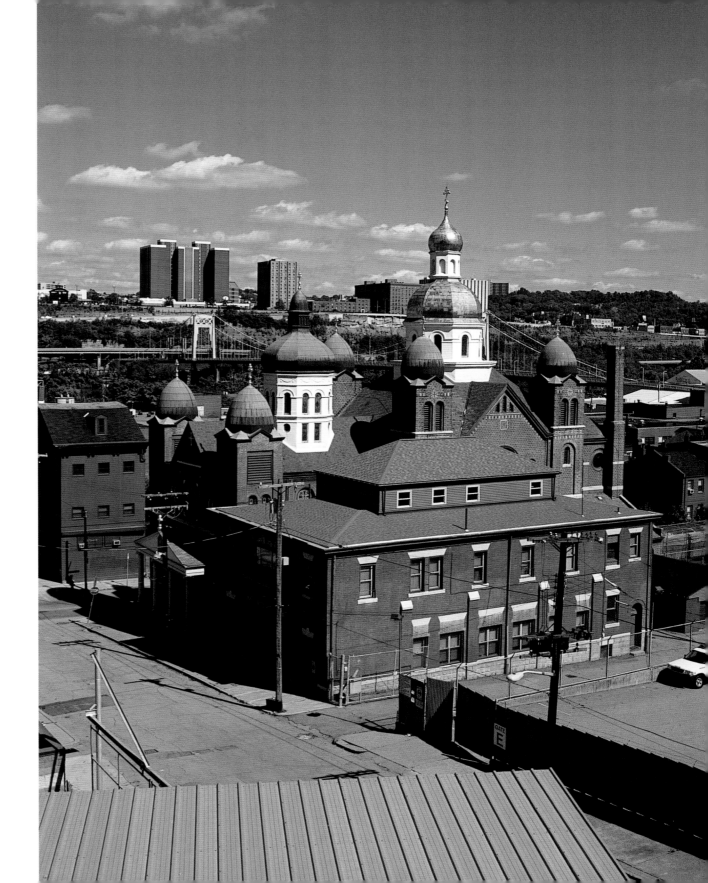

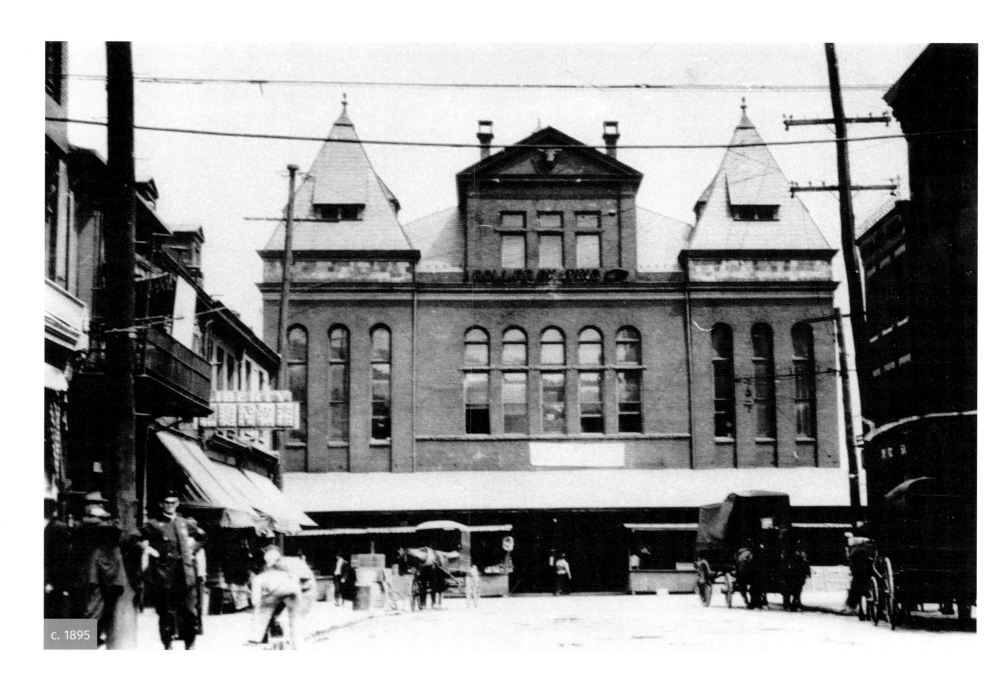

c. 1895

BEDFORD SQUARE

Named after the nineteenth-century developer responsible for Birmingham

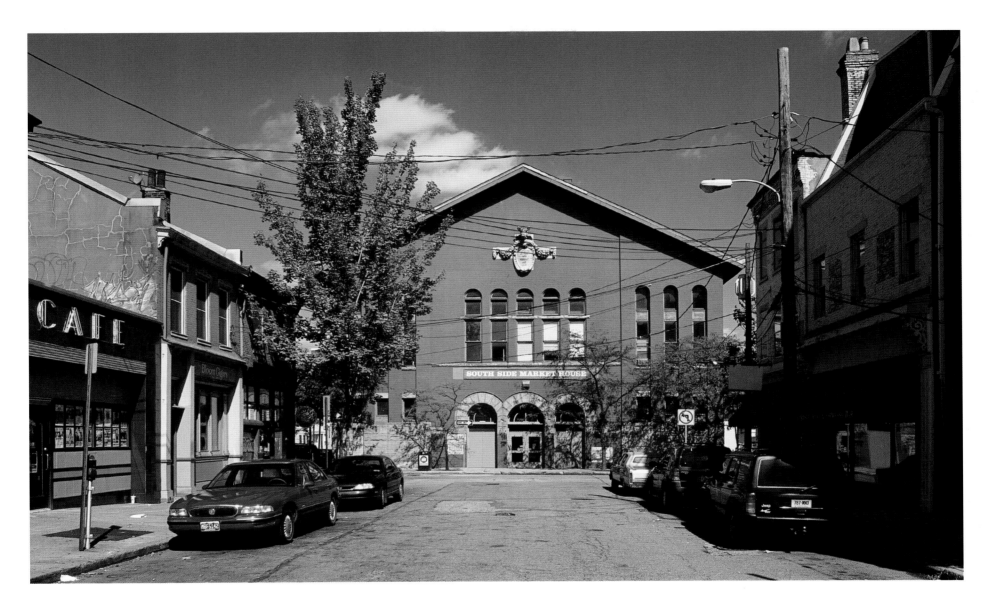

LEFT: In 1811, Nathaniel Bedford laid out a little town called Birmingham, which extended between what are now South Sixth and South Seventeenth streets. (His relatives in the Ormsby family extended the development further east: first to South Twenty-seventh Street as East Birmingham, then even further eastward as Ormsby.) On South Twelfth Street, Bedford put a marketplace, Bedford Square. In 1891 the market house shown here was constructed—a more or less Romanesque work by Charles Bickel, a prominent, prolific Pittsburgh architect.

ABOVE: In 1915 the market house was simplified and classicized after a fire. A handsome cartouche with the words "Destroyed by fire and rebuilt AD 1915" was placed under the original bull's head as a central decorative feature. The architect was probably Stanley Roush, who had treated the Corliss Street Tunnel portal in a similar way two years before. The market house is now a community center. Some of the commerce in and near this little square gives an idea of its mixed character today: blue-collar in much of its commerce and housing, even though the industry has left.

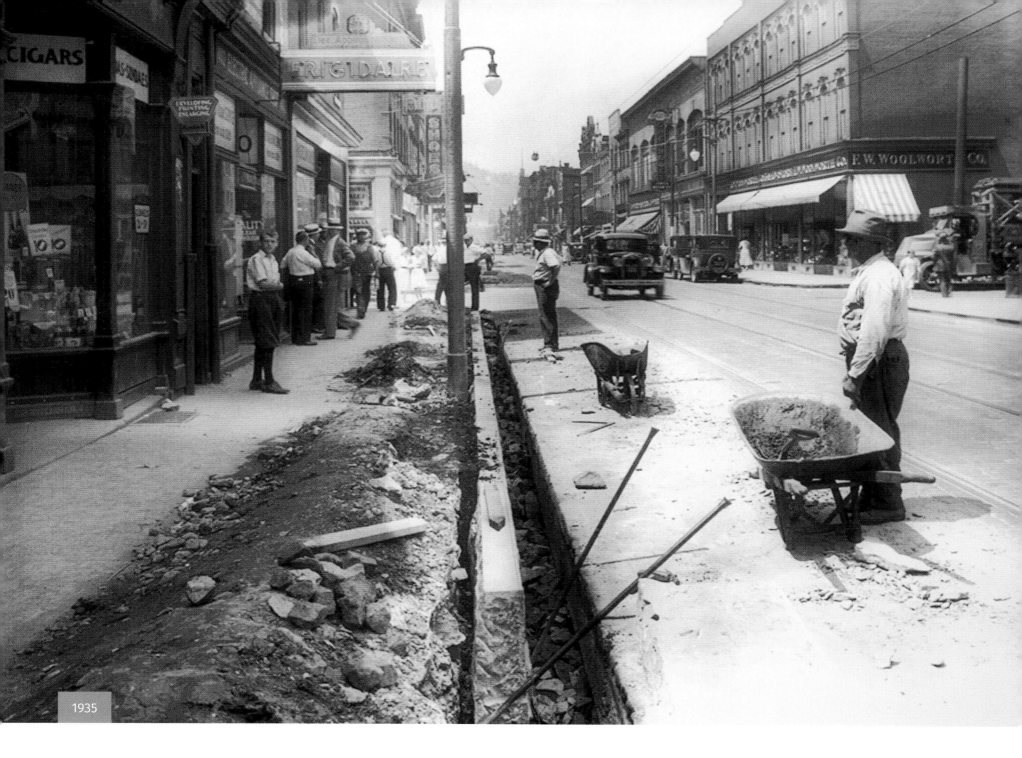

1935

CARSON STREET

Designated a City Historic District, Carson Street has kept its main street appeal

LEFT: A covered wooden bridge crossed the Allegheny River at Sixteenth Street, connecting Chestnut Street in the Deutschtown part of the North Side with the Strip district, a long, narrow area of river plain seen in the distance. The bridge had a challenging life: first built in 1837, it had to be rebuilt after an 1851 fire, and again after a flood in 1865. Deemed an obstruction to navigation in 1917, the bridge was destroyed by fire in 1919. The Strip was an intensely active, extremely smoky industrial quarter, with a promiscuous blend of furnaces, industrial sheds, railroad buildings, houses, and churches. The twin towers of the third St. Patrick's church are visible. Andrew Carnegie established his Union Iron Mills in the Strip in 1867; George Westinghouse located his Air Brake Company there in 1871; and aluminum was first refined at an affordable price by the Pittsburgh Reduction Company in 1888.

ABOVE: In 1923 a new Sixteenth Street Bridge was constructed and was intended this time as a work of architecture. Its three heavily trussed spans bridged a void of little more than 800 feet, but created a grand effect, made all the grander by symbolic stone abutments designed by Warren & Wetmore, architects of Grand Central Station in New York, topped by armillary spheres and leaping sea horses in bronze by Leo Lentelli. The bridge was renamed in 2013 for Pittsburgh native David McCullough, a Pulitzer Prize-winning author, historian, narrator, and lecturer. The Strip, bordered by a riverfront trail and Herron Hill, is now famous for its pleasingly haphazard mix of ethnic stores, restaurants, nightclubs, and residences in renovated buildings. The Pittsburgh Opera is headquartered in the former Westinghouse Air Brake Building; the Senator John Heinz History Center is located in a former ice warehouse; and the Society for Contemporary Craft occupies a portion of the former produce terminal.

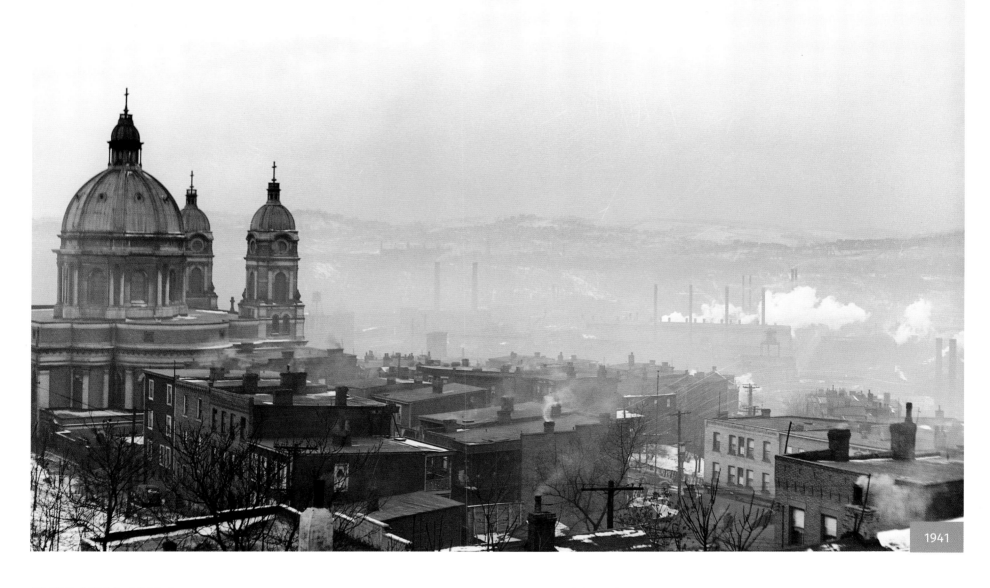

1941

POLISH HILL

One of Pittsburgh's many ethnic neighborhoods with a European character

ABOVE: Polish Hill, first settled around 1885, occupies a curious place between the Strip down by the Allegheny River and the Hill, the neighborhood that rises eastward from the Triangle. An early sign of the permanence of this workers' neighborhood is the Church of the Immaculate Heart of Mary, shown here in 1941, three decades after its construction in 1906. The tall, slender chimneys are probably on Herr's Island, which was occupied early in the century by the Pittsburgh Melting Company, the Allegheny Garbage Company, and a stockyard and slaughterhouse.

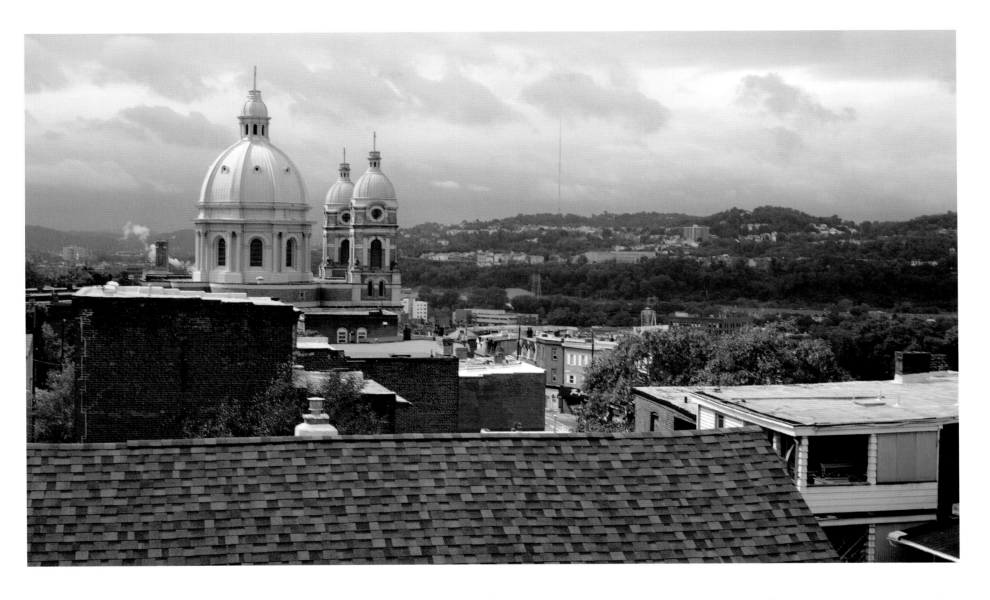

ABOVE: Polish Hill remains a stable, attractive neighborhood, one of ninety (or so) in the City of Pittsburgh. Immaculate Heart of Mary Church, with a dome space ninety-eight-feet high inside, continues to serve the surrounding community. Residents have wonderful views of the Allegheny River Valley, but no longer see the chimneys from Herr's Island industry. The island has been renamed and redeveloped. It is now called Washington's Landing, in honor of George Washington who spent the night there after he fell off his raft while crossing the Allegheny River on

December 29, 1753. (Guide Christopher Gist was with Washington and rescued him from the icy waters.) Washington's Landing is one of the city's first and most successful brownfield-to-residential mixed-use redevelopments. There are townhomes, condominiums, landscaped trails, offices, a restaurant, marina, and the Three Rivers Rowing Association and Western Pennsylvania Conservancy. In the distance, the predominantly German neighborhood of Troy Hill rises above Pennsylvania Route 28.

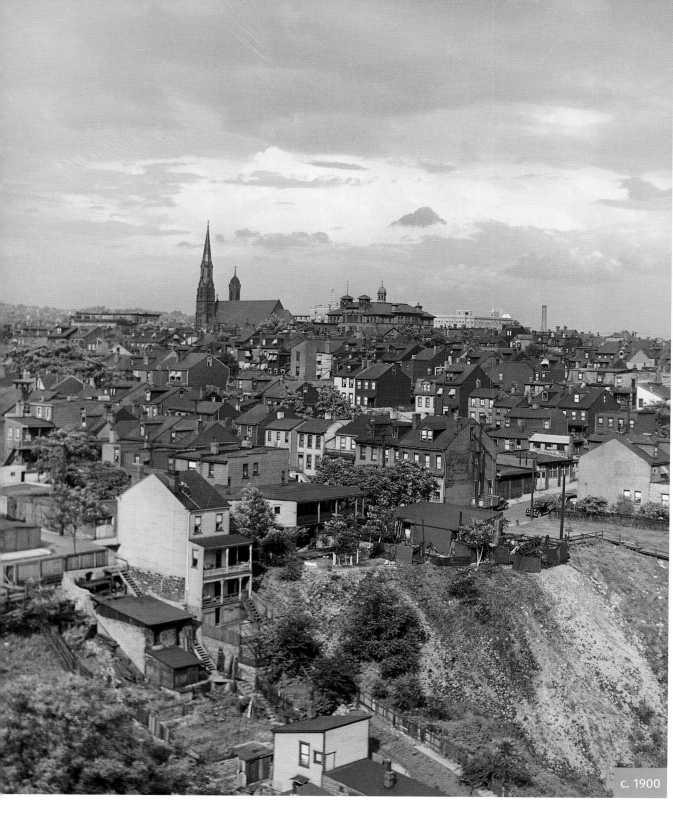

c. 1900

BLOOMFIELD
Pittsburgh's own "Little Italy"

LEFT: A view from the Bloomfield Bridge to the neighborhood of Bloomfield and particularly toward St. Joseph's Church on Liberty Avenue, with its school. This is a neighborhood of little frame houses on little lots, lacking the bourgeois amplitude of Friendship or East Liberty, both to the east. It gains distinction, though, from some institutions on Penn Avenue at its northwest corner: Allegheny and St. Mary cemeteries.

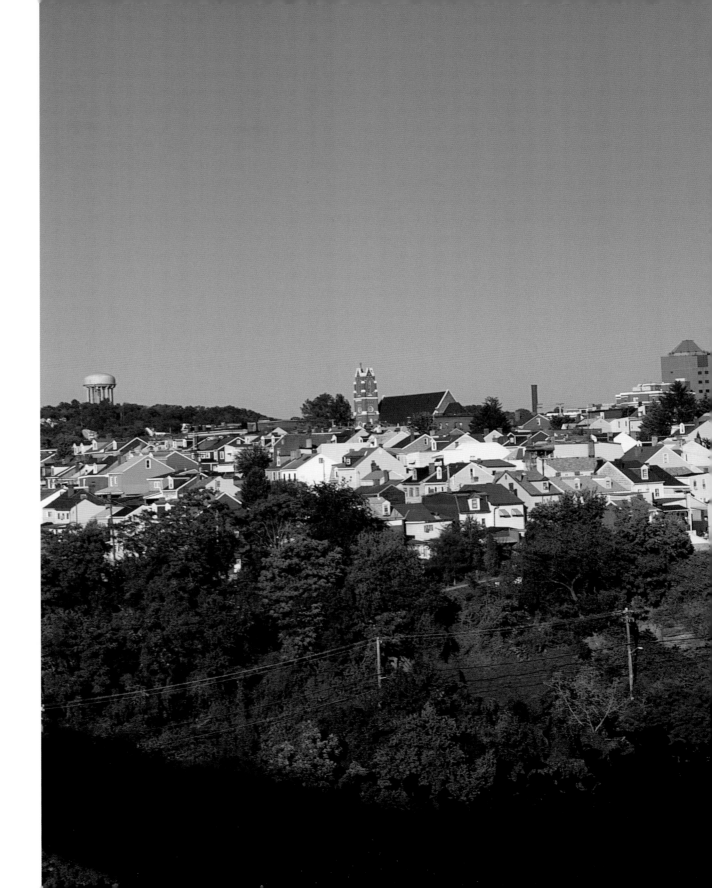

RIGHT: Bloomfield, Pittsburgh's own "Little Italy," has much of its old basic texture, though white aluminum and asphalt siding have replaced the old painted wooden siding in its various shades. St. Joseph's Church has lost its spire and its school. On the horizon is the Garfield Elevated Tank, with a million and a half gallons of municipal water. Over to the far right is a building of West Penn Hospital, one of the two hospitals at the edge of Bloomfield.

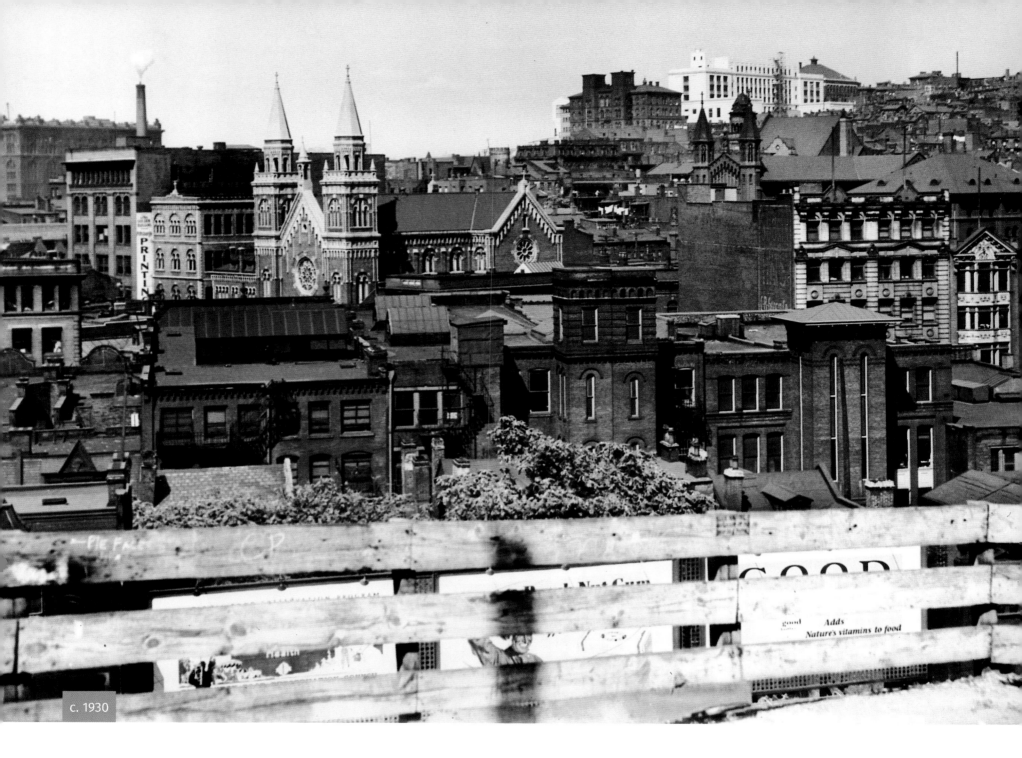

c. 1930

LOWER HILL
Church of the Epiphany still anchors the scene

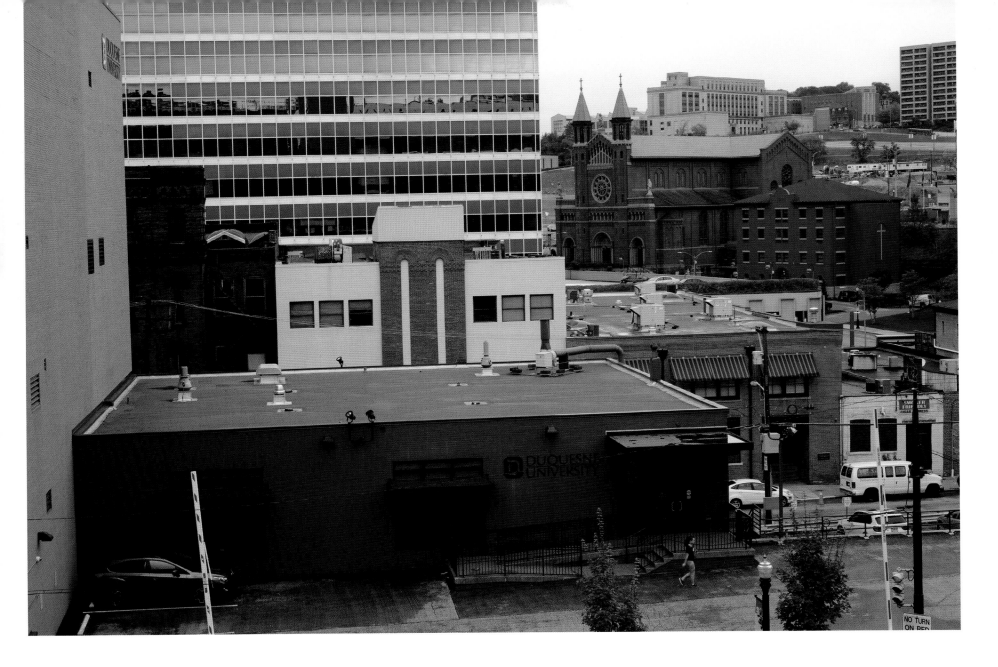

LEFT: The land that rises from the Triangle inland from both the Allegheny and Monongahela rivers is known as the Hill: a sprawling area that has housed little colonies of ethnic groups. Its prominence has tempted civic leaders to visions of a cultural acropolis. Here is the Lower Hill around 1930. Union Station appears on the skyline to the back left, and on the skyline to the right are the old Central High School in its last days and the new Connelley Trade School. St. Peter's Roman Catholic Church, built in 1918, dominates the scene, and the twin towers of the Church of the Epiphany, built in 1902, are higher on the Hill to the right.

ABOVE: Clearances of the historic Lower Hill for urban renewal began in 1956, and the red-brick Italian Romanesque Church of the Epiphany and Connelley Trade School—now the Energy Innovation Center—are among the sole survivors. The developers of the Energy Innovation Center donated an easement to the Pittsburgh History & Landmarks Foundation in 2012 to protect the exterior of the National Register-listed building. Duquesne University has expanded from the Bluff to occupy buildings along Forbes Avenue. Part of Chatham Center, a commercial and residential building complex from the 1960s, is at top left. Chatham Center was named for Pittsburgh's namesake, William Pitt the Elder, Earl of Chatham.

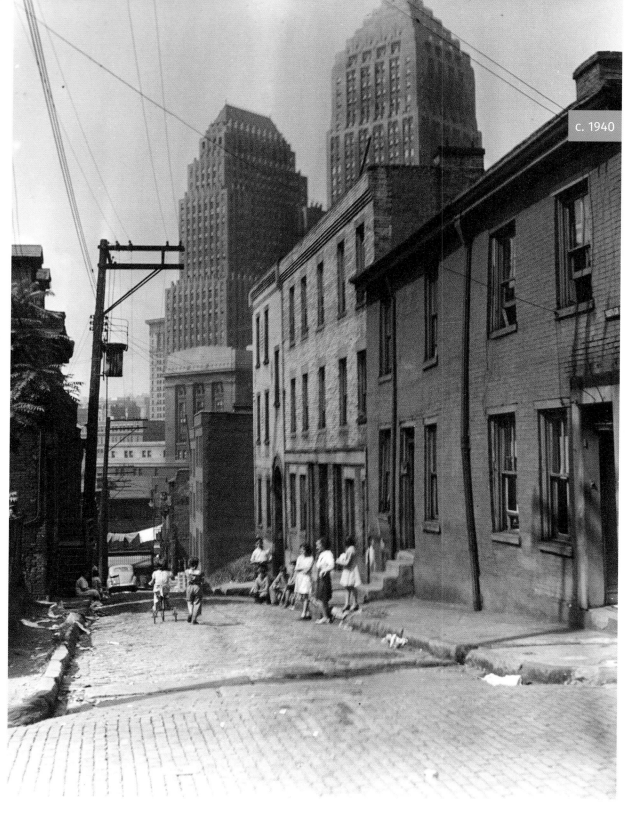

c. 1940

LOWER HILL
The neighborhood was cleared to create a cultural center, only partially realized

LEFT: Bustrick Way was situated as if to point out the contrast between the glamorous new architecture of Grant Street and the humble streets of the Lower Hill. A 1930s theater set could hardly do better, especially on some evening when the architectural lighting of the Koppers Building, to the left, played over its tall, hipped roof: proud, aloof, bourgeois architecture and the humble abodes of the people. The Hill became a place of many cultures and many levels of prosperity. The 1940s census listed twenty-five nationalities in the Hill, including African Americans who predominated, and Jews, Syrians, Armenians, Lebanese, Greeks, Italians, and Irish.

RIGHT: Beginning in 1956 the Lower Hill was almost totally cleared of its homes and stores and most of its religious buildings: a measure whose justice is still in dispute and that did not lead to the acropolis of centralized culture housed in modern architecture that the civic leaders had anticipated. Bustrick Way was obliterated and even its precise location is now inaccessible. This view is from further back, on Flag Plaza in front of the Boy Scout headquarters. Pulitzer Prize-winning playwright August Wilson, who grew up in the Hill, incorporated the often tragic themes of displacement and community redevelopment in his series of ten plays, the *Pittsburgh Cycle*. Wilson set nine of his plays in the Hill, and each explores the African American experience during a particular decade of the twentieth century.

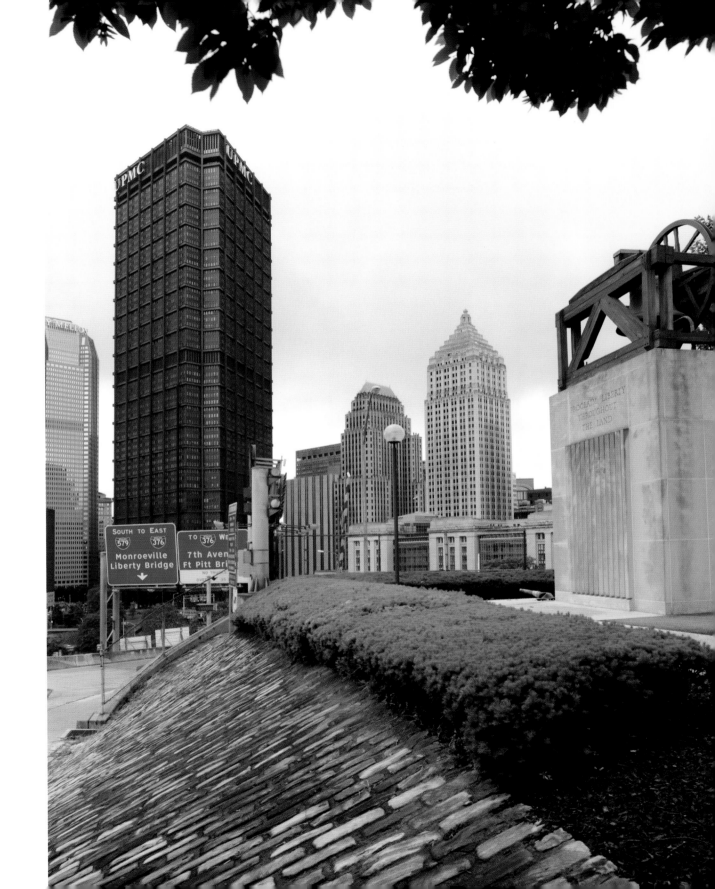

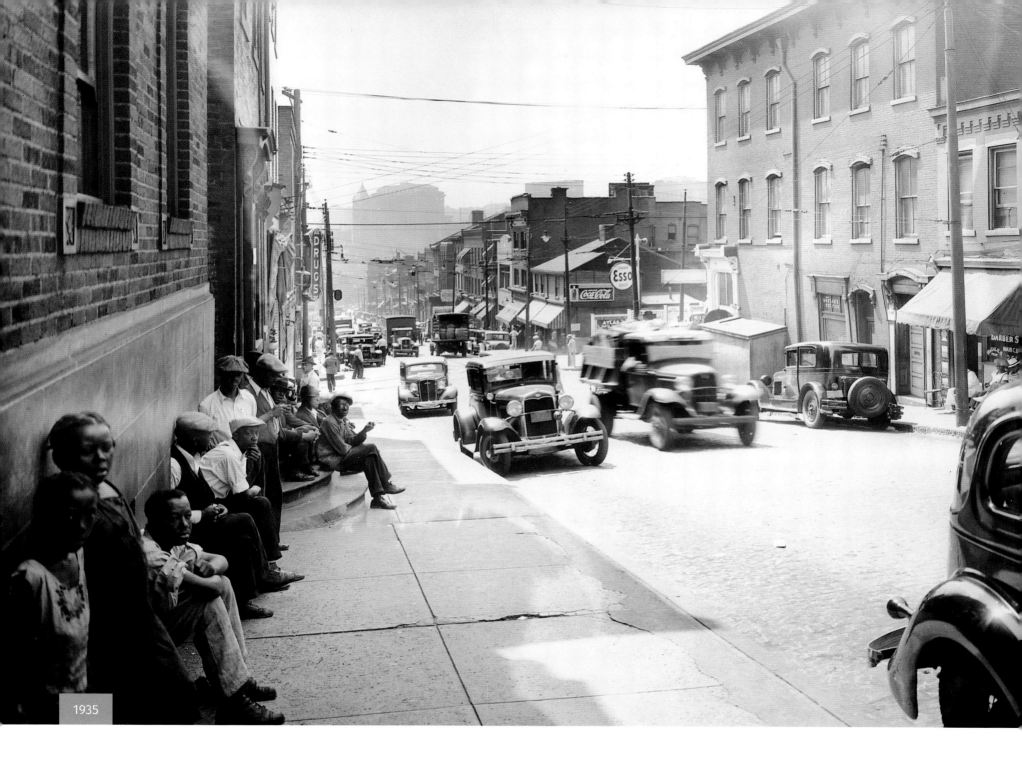

1935

WYLIE AVENUE

Referenced in six of the nine plays August Wilson set in Pittsburgh's Hill

106

LEFT: Wylie Avenue is one of the main streets of the Hill, and this view southwest from the 1500 block shows it in 1935. The Allegheny County Courthouse tower and Frick Building, downtown, are seen in the distance. The Hill was the city's major African American neighborhood in the 1930s, but housed only 41 percent of the city's African American residents. The streets filled with cars suggest a modest prosperity, and a nostalgic video, *Wylie Avenue Days* (1991), suggests that life before urban renewal was acceptable for most. The 1936 Pittsburgh Crawfords, a baseball team that emerged from integrated neighborhood clubs in the Hill, boasted five eventual Hall of Famers—Satchel Paige, Josh Gibson, "Cool Papa" Bell, Oscar Charleston, and Judy Johnson.

ABOVE: The modern residential architecture of Crawford Square (obscured by trees) now faces Wylie Avenue, which ends at Crawford Street and no longer continues into downtown Pittsburgh. Nearly everything beyond Crawford Street in the historic Lower Hill was demolished in the late 1950s for the construction of the Civic Arena (completed in 1961), Washington Plaza Apartments, and Chatham Center. The multipurpose civic auditorium, home to the Pittsburgh Penguins, was demolished in 2011–12, after the Penguins constructed Consol Energy Center across Centre Avenue. The former site of the Civic Arena is now being redeveloped in a way that connects the Hill with downtown Pittsburgh once again.

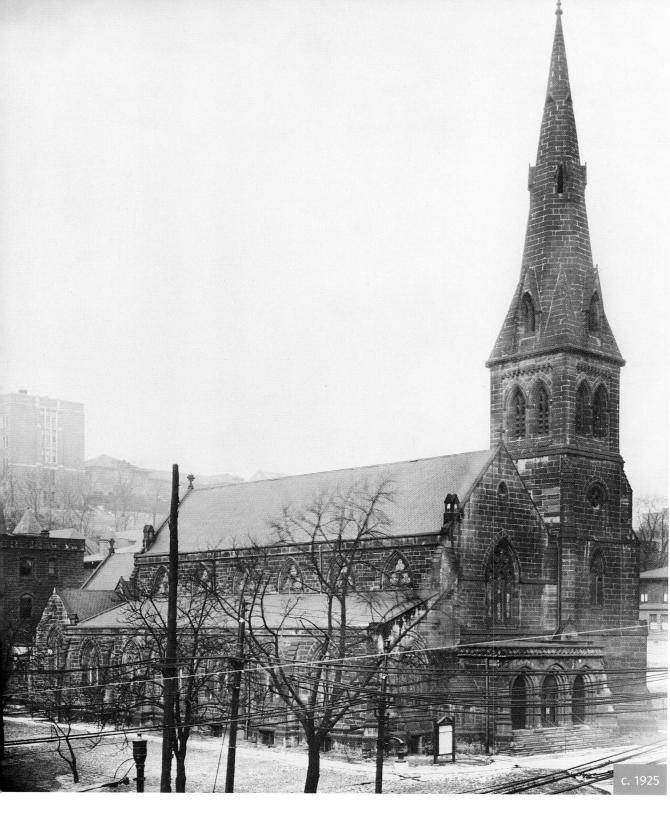

c. 1925

ST. PETER'S CHURCH / CARLOW UNIVERSITY

The church was moved here, stone by stone, from Grant Street

LEFT: St. Peter's Episcopal Church, designed in 1851 by the Philadelphia architect John Notman, ended up at Forbes Street and Craft Avenue in Oakland after Henry C. Frick paid for its move from Grant Street in 1901. Here, in a 1920s photograph, is St. Peter's shown with a porch added after the move. Across Forbes was a car barn for the Pittsburgh Railways Company, with the Elizabeth Steel Magee Hospital behind it. Other neighbors were the St. Agnes Church and the Ursuline Young Ladies' Academy (both Catholic), a few hillside mansions that were in their last days, and a great many middle-class builders' houses.

RIGHT: Little used at the end, St. Peter's was demolished in 1991, and Carlow University, originally the Ursuline Young Ladies' Academy and later Mount Mercy, built the A. J. Palumbo Hall of Science and Technology in its place. The car barn across the street has long departed, and Magee Women's Hospital of UPMC has expanded to fill that whole block. The crane marks the location of SkyVue, an apartment complex completed in 2016, on the former site of the Allegheny Health Department.

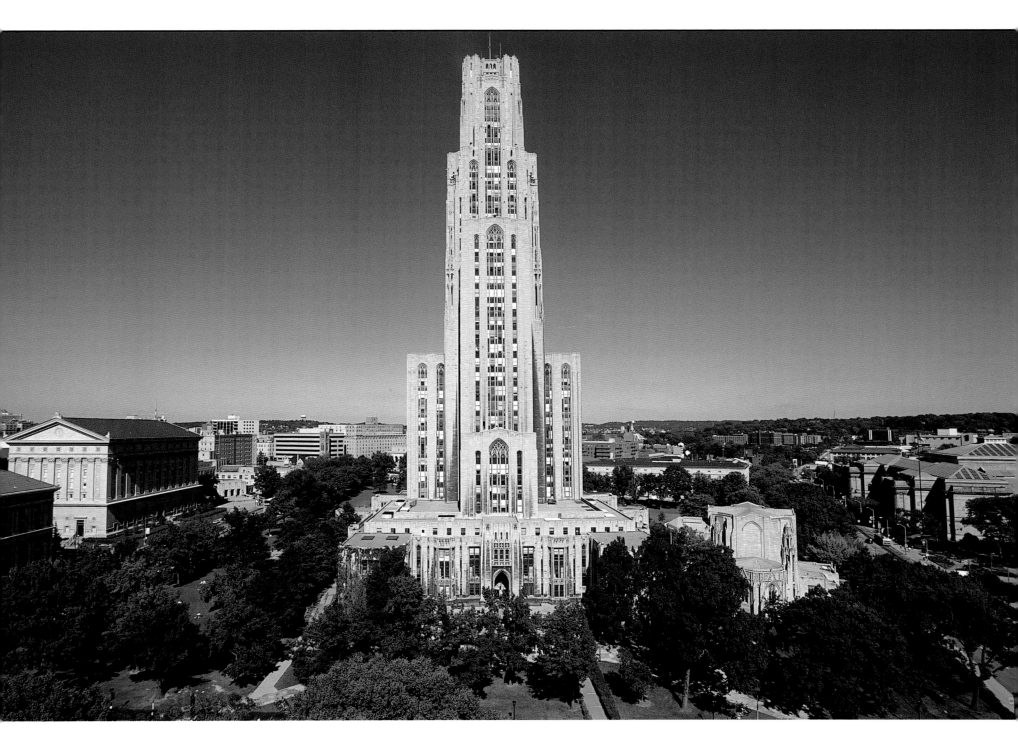

HOTEL SCHENLEY / WILLIAM PITT STUDENT UNION

Pittsburgh's first large, steel-framed "skyscraper hotel"

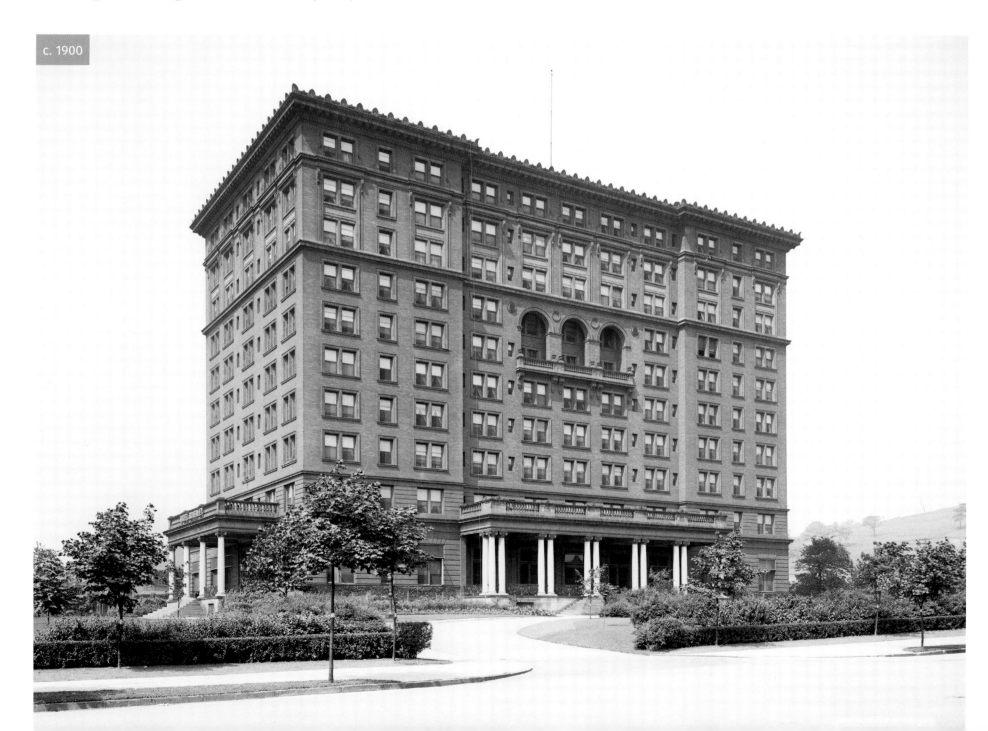

c. 1900

LEFT: Designed in 1898 by Rutan & Russell, a prominent local firm, Hotel Schenley was Pittsburgh's most elegant hotel. The Classically inspired, tawny brick and terra-cotta building was surrounded by landscaped grounds designed by Olmsted Brothers. Visiting artists performing at the Syria Mosque a half-block away would stay here, as well as baseball teams playing at nearby Forbes Field. Inside, the public rooms were spacious and ornate, with a considerable use of marble in the lobby. The hotel developer was Franklin Nicola. Nicola also developed the Schenley Farms residential district beginning after 1904, Forbes Field (1909), and the Pittsburgh Athletic Association (1911). He envisioned Oakland as a civic center, several miles from and about 200 feet above smoky, congested, downtown Pittsburgh.

BELOW: The University of Pittsburgh acquired the Hotel Schenley in 1956, renovated and remodeled the interior at various times, and renamed it the William Pitt Student Union in 1983. Now the hub of university activity, the ten-story building includes lounges, ballrooms, and reception, performance, and meeting spaces. The main floor ballroom features the original vaulted ceiling, mirrored walls, grand crystal chandeliers, and moldings and artwork from the hotel. A bronze tablet, sculpted by Frank Vittor, honors Italian actress Eleanora Duse, who died there unexpectedly in 1924. Other famous guests have included Soviet leader Nikita Khrushchev, who visited in September 1959, and Martin Luther King, Jr., who spoke to Pitt students and faculty on November 2, 1966.

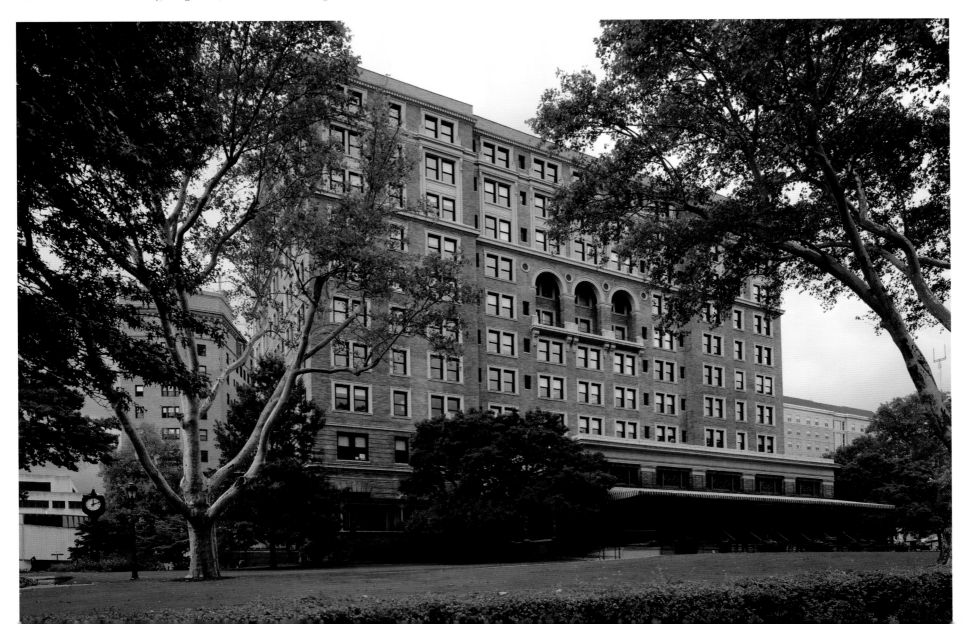

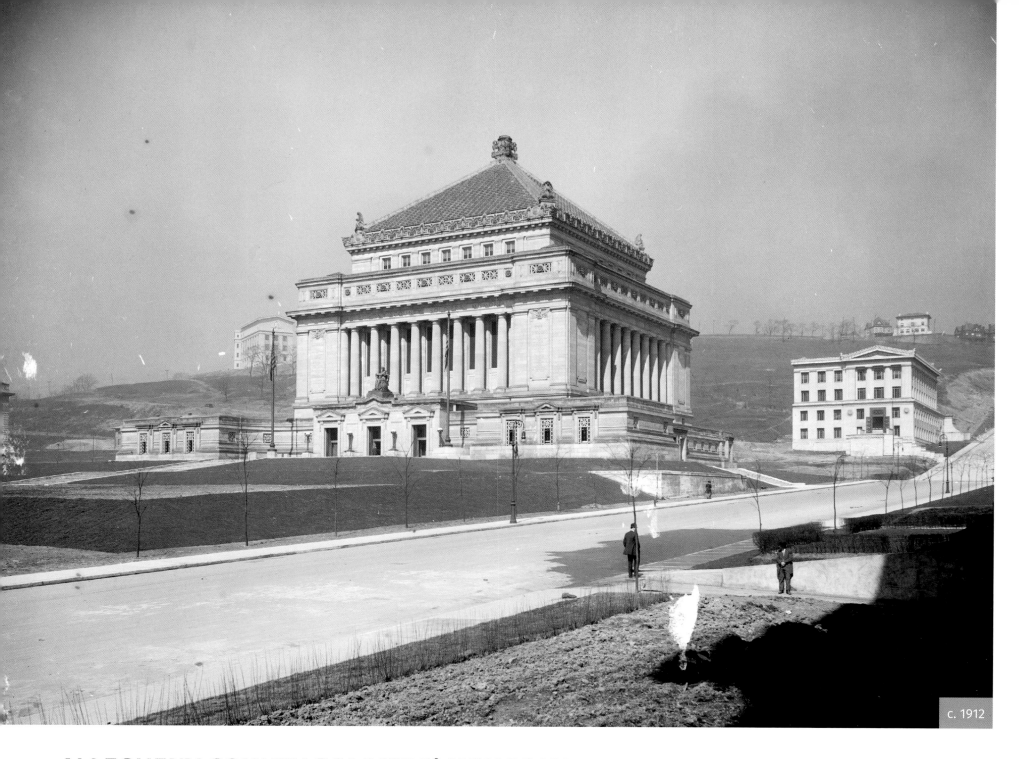

c. 1912

ALLEGHENY COUNTY SOLDIERS' MEMORIAL

A memorial hall and national military museum

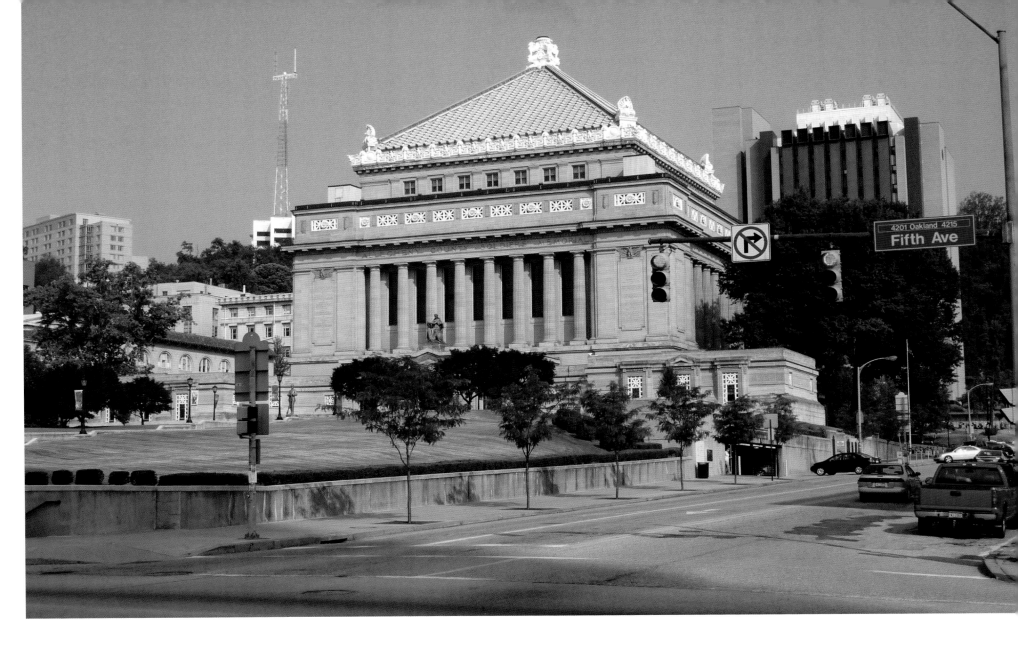

LEFT: James S. Sherman, the Vice-President of the United States, attended the public dedication in 1910 for the Allegheny County Soldiers' Memorial, honoring county citizens who served in the Civil War. Brooklyn-born and Beaux-Arts-trained architect Henry Hornbostel won the design competition and modeled the memorial hall after the Mausoleum at Halicarnassus, one of the seven wonders of the ancient world. The central mass of light-colored sandstone and terra cotta holds an auditorium, with a clerestoried banquet hall above, beneath the pyramidal tiled roof. Charles Keck's *America* sits enthroned over the central doorway. The memorial illustrates Beaux-Arts design in its grandest mode: symmetrical, impressive in massing, rich in detail.

ABOVE: Rededicated in 1963 to honor veterans of all wars, Soldiers & Sailors Memorial Hall and Museum rises above Fifth Avenue, in the midst of the University of Pittsburgh's Oakland campus. Operated by a nonprofit organization, Soldiers & Sailors is the nation's only military memorial dedicated to honoring the men and women of all branches of service, from all generations and conflicts. The landmark building is listed on the National Register of Historic Places, is a City-Designated Historic Structure, and is included in the Oakland Civic Center City-Designated Historic District. Many graduations and memorial services are held in the 2,300-seat concert auditorium where Abraham Lincoln's Gettysburg Address is painted as a mural above the stage.

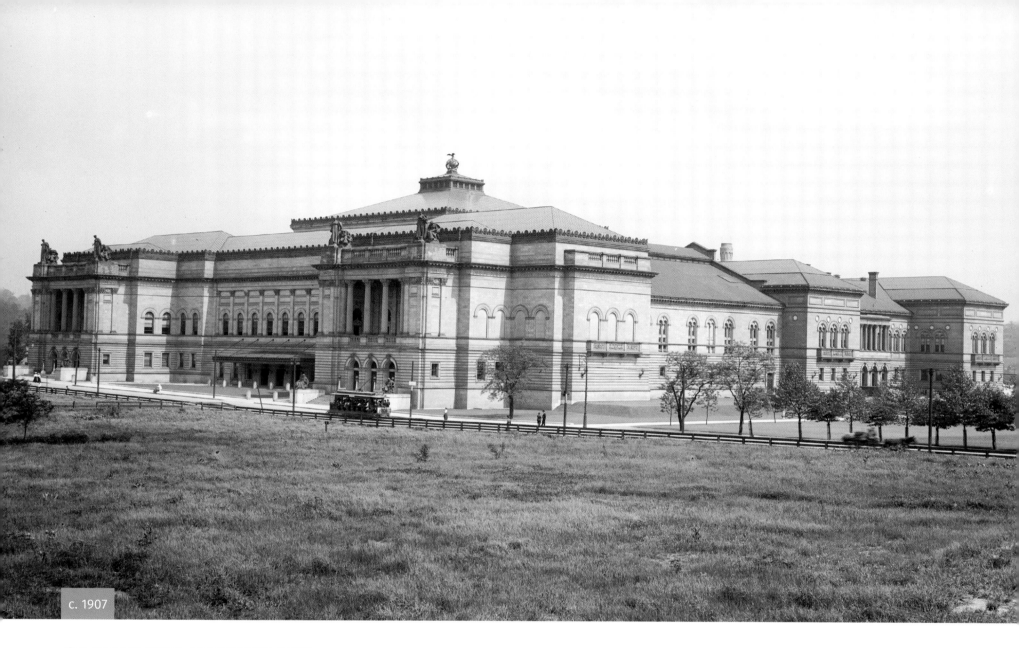

c. 1907

CARNEGIE INSTITUTE

Andrew Carnegie's "Palace of Culture" for the people of Pittsburgh

ABOVE: In 1889 Pittsburgh's director of public works, Edward Manning Bigelow, roused a friend from his sleep—so the story goes—and had him race a developer's agent to Mary Schenley's home in London to beg for 300 acres of wild land to be made into Pittsburgh's first real park. The lady agreed, and Andrew Carnegie renewed an earlier offer of a cultural institution at the main entrance to the park. An architectural competition held in 1891 resulted in the first part of the Carnegie Institute, an omnibus building by Longfellow, Alden & Harlow that included a public library, art museum, museum of natural history, and music hall. This opened in 1895 and, along with Schenley Park (created in 1889), was Pittsburgh's first attempt at the City Beautiful. But there was demand for even more space, and between 1903 and 1907 the size of the Carnegie Institute was tripled, with most of the work along Forbes Avenue. The architects were Alden & Harlow, successors of the original office.

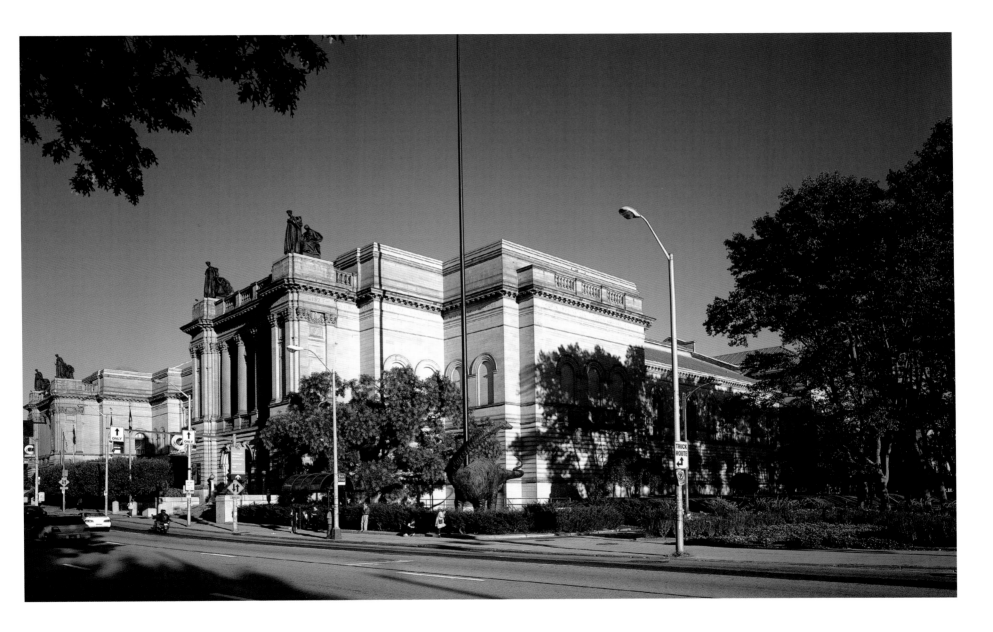

ABOVE: The 1907 expansion along Forbes Avenue was designed with a pomp unknown in the 1895 building, and included imposing entrances for a new music hall and for a much-enlarged museum. Bronze statuary by James Massey Rhind and murals by John White Alexander added to this new splendor, and Andrew Carnegie gave the music hall a marble-lined foyer allegedly calculated to cost more than any European throne room. A further expansion along Forbes Avenue in the early 1970s (out of view to the far left) gave the Carnegie Museum of Art a new home in a sensitively designed addition by Edward Larrabee Barnes. The Carnegie Music Hall and Carnegie Museum of Natural History, famous for its Hall of Dinosaurs, Hall of Architecture, and The Heinz Architectural Center, now fill the historic 1907 building. The Carnegie Library of Pittsburgh fills the original 1895 building (far right).

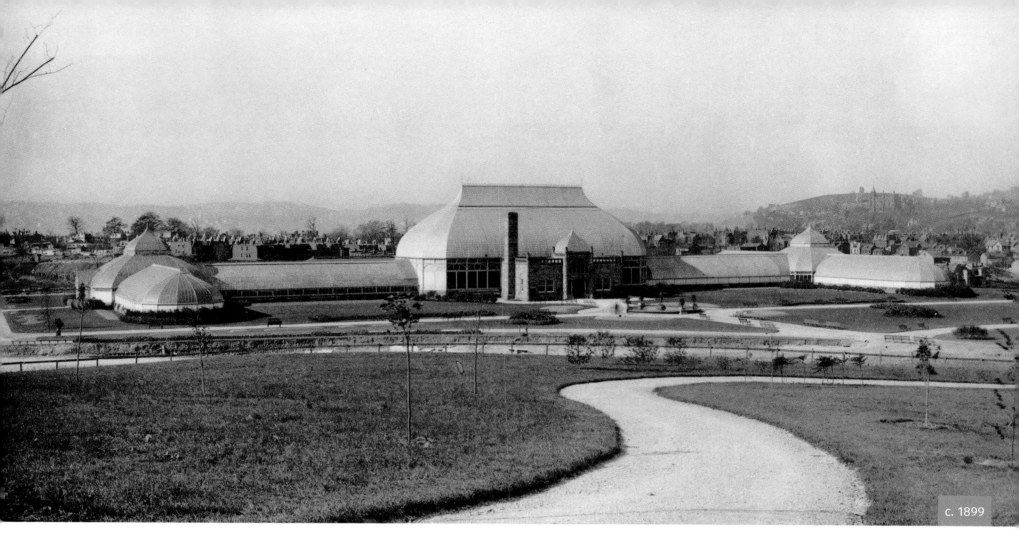

c. 1899

PHIPPS CONSERVATORY

Today the greenest of greenhouses

ABOVE AND RIGHT: Henry Phipps, a boyhood friend and later a business partner of Andrew Carnegie, in the early 1890s commissioned a conservatory for Schenley Park. Lord & Burnham, a Tarrytown, New York, firm of conservatory designers and builders, was chosen for this handsome new facility. The result was a glass palace with a stone forebuilding that was mostly Romanesque, with a little Renaissance detailing. The view above is from Flagstaff Hill, a long, gently rising meadow in Schenley Park.

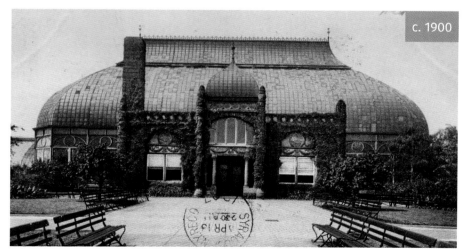

c. 1900

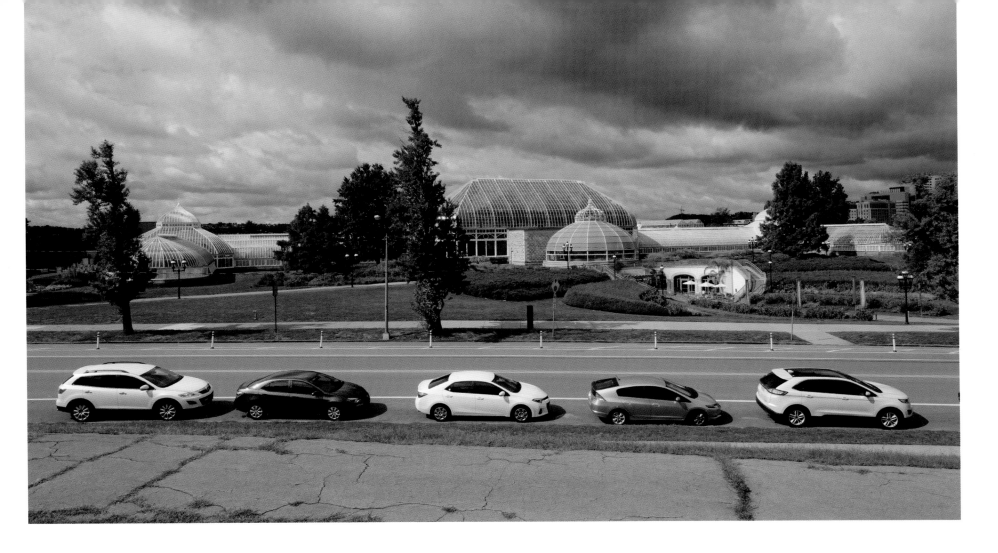

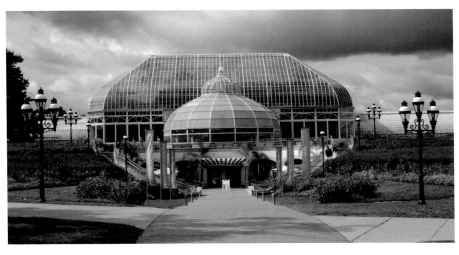

ABOVE AND LEFT: Phipps Conservatory and Botanical Gardens has grown in dramatic ways from its founding in 1893. Beginning in 1975, the Pittsburgh History & Landmarks Foundation and an auxiliary volunteer committee began raising funds to restore the historic glasshouses, in collaboration with the City. In 1985 an independent nonprofit was formed. Phipps now includes a Welcome Center addition (2005) topped by a neo-Victorian dome, the Production Greenhouses and a Tropical Forest Conservatory (2006), and the Center for Sustainable Landscapes (2012), one of the "greenest" buildings in the world: it generates its own energy (with solar panels, wind turbines, and geothermal wells) and treats all storm and sanitary water. Attending the seasonal flower shows at Phipps is a Pittsburgh tradition, drawing generations of family members together. One of the most familiar spaces is the Palm Court, with its high glass peak that accommodates many species of palm trees. Several were sent by train from Chicago to Pittsburgh from the 1893 World's Columbian Exposition.

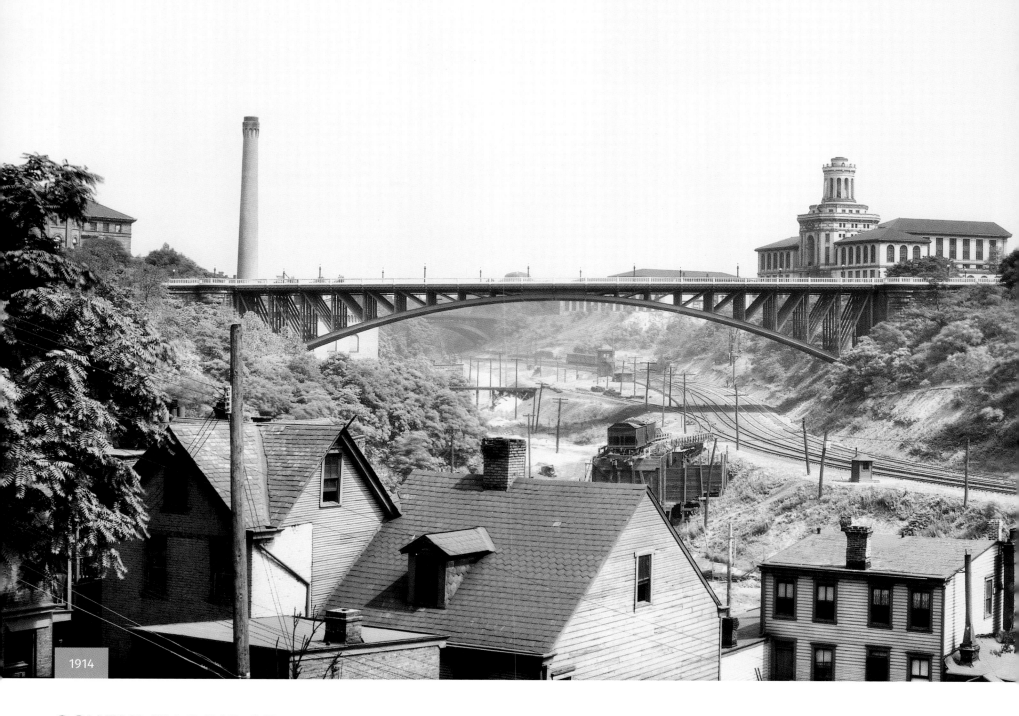

1914

SCHENLEY BRIDGE

Spanning Junction Hollow

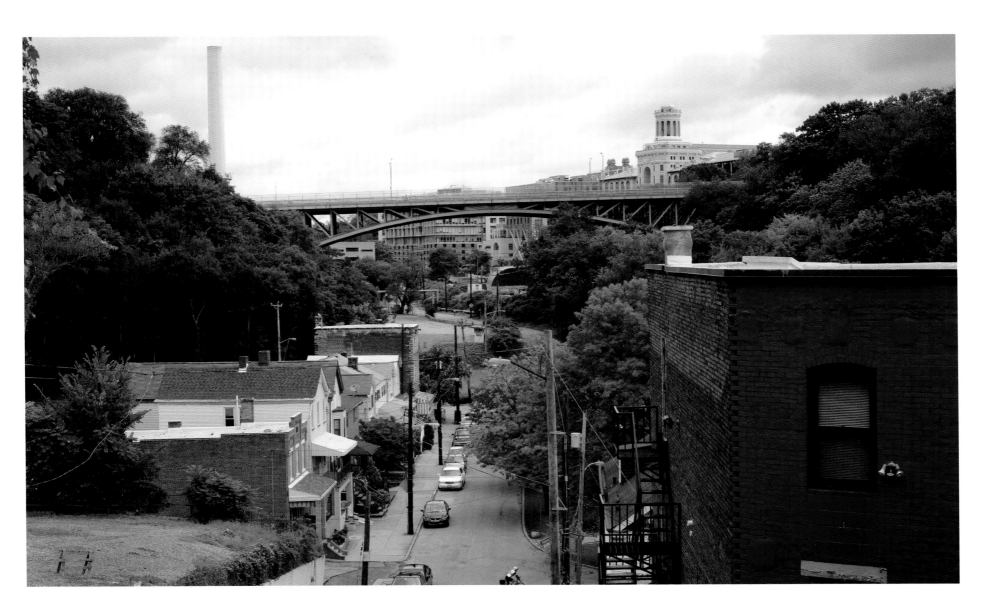

LEFT: This view from June 1914 sums up some of the city's contradictory character. At the far left edge is the Carnegie Institute and to the right is Machinery Hall of the Carnegie Institute of Technology, bright—so far—in its new white brick and terra cotta. Between them is Junction Hollow, a ravine with a railroad line and a boiler plant sharing space with workers' houses, a few industrial structures, and many wild plants. Spanning the Hollow is the handsome Schenley Bridge.

ABOVE: To the tidy minds of some during the Pittsburgh Renaissance, Junction Hollow was merely wasted space, and a plan was made to fill it flush with offices, classrooms, and laboratories, with an arterial road in the railroad's place. This never came to be, but the Hollow still appears to some merely as space to be filled as proves expedient. A building of the 1990s partly conceals the front of Machinery (now Hamerschlag) Hall of what is now Carnegie Mellon University, and more is on the way. The Schenley Bridge now has federally required chain-link fencing along its walk.

1937

FORBES STREET / FORBES AVENUE
Today overlooked by Ajax, Babo, and Comet

BAUM BOULEVARD

Staking a claim as the world's first drive-in filling station

LEFT: Further out on Baum Boulevard at South St. Clair Street one could see a sight like this around 1925. Baum Boulevard (or Atlantic Avenue or Atherton Avenue at various times) had started out as a solidly bourgeois street close to the Pennsylvania Railroad's commuter stations, but had been massively invaded by the automobile business as early as 1905. Pittsburghers believe this to be the world's first drive-in filling station.

ABOVE: The celebrated gas station is gone, and while some of the architecture made for the car still exists, some of it has been adapted for other uses. The automobile dealership has been renovated as the Spinning Plate Artist Lofts, including loft, studio, and gallery space. There is a little surviving of the corner's architectural treatment (painted purple and minus any context), but otherwise the corner lot seems to serve only for parking these days.

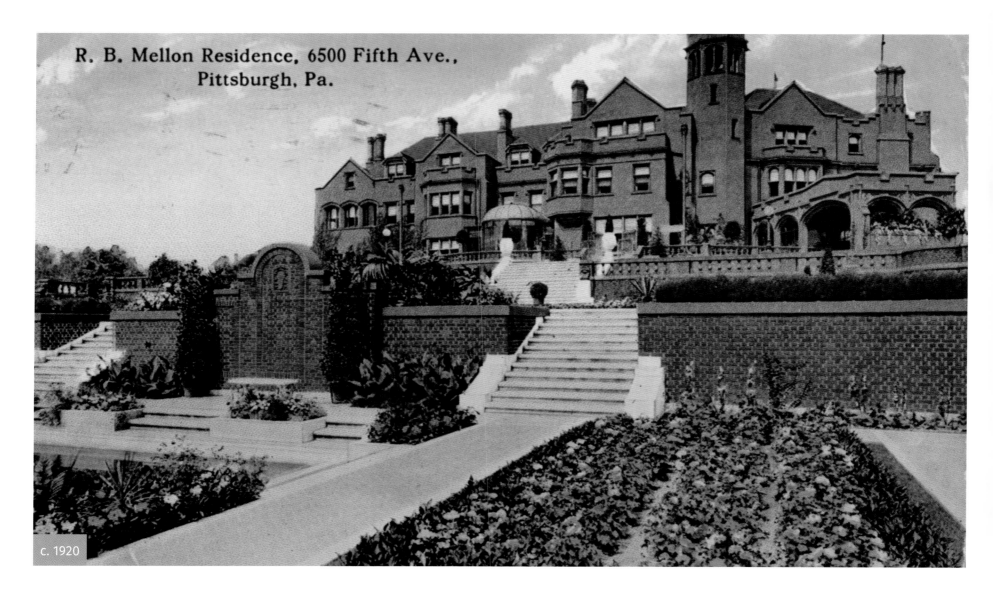

R. B. Mellon Residence, 6500 Fifth Ave., Pittsburgh, Pa.

c. 1920

R. B. MELLON RESIDENCE, FIFTH AVENUE

A grand Tudor-style residence that came down in the 1940s

ABOVE: Fifth Avenue east of the Oakland Civic Center was a municipal showplace, with many of the city's prosperous in residence, but no house quite matched that of Richard Beatty and Jennie King Mellon, at Fifth Avenue and Beechwood Boulevard in an area claimed for both Shadyside and Squirrel Hill. A work in the Tudor style by Alden & Harlow, it was finished in 1911. It had a "butterfly plan" that offered a variety of views and abundant workmanship that included a fine marble staircase. Its garden terraces toward Beechwood Boulevard were remarkable in their own right.

1905

1900

FAR LEFT AND LEFT: Edward Manning Bigelow, Pittsburgh's director of public works, began Highland Park in 1889, the same year he started Schenley Park. Highland Park is north of East Liberty overlooking the Allegheny River. One rationale for its existence was the protection of the main reservoirs for the city's water supply. The main image dates from around 1906, and the view is looking south from the bank of Reservoir No. 1 (which was elaborately planted with changing flower displays) toward the main entrance from Highland Avenue. The huge gate piers date from 1896 and bear Giuseppe Moretti's bronzes of wreath-waving ladies, babies, and eagles.

ABOVE: The Pittsburgh Parks Conservancy restored the formal entry garden in Highland Park in 2005. The fountain, reflecting pool, walkways, and gardens were renewed, and lighting, benches, and elegant trellises added. This photo is taken from a stone staircase that leads to a huge reservoir, on an upper level of the park. Although there was talk of covering the Highland Park Reservoir with a giant plastic sheet to maintain water purity, community residents led a successful counter-effort to have a new water filtration plant and "babbling brook" landscape feature constructed instead. Residents and visitors still enjoy a pleasant walk around the vast expanse of Reservoir No. 1.

WEST END

Formerly known as Temperance Village, alcohol was prohibited until 1872

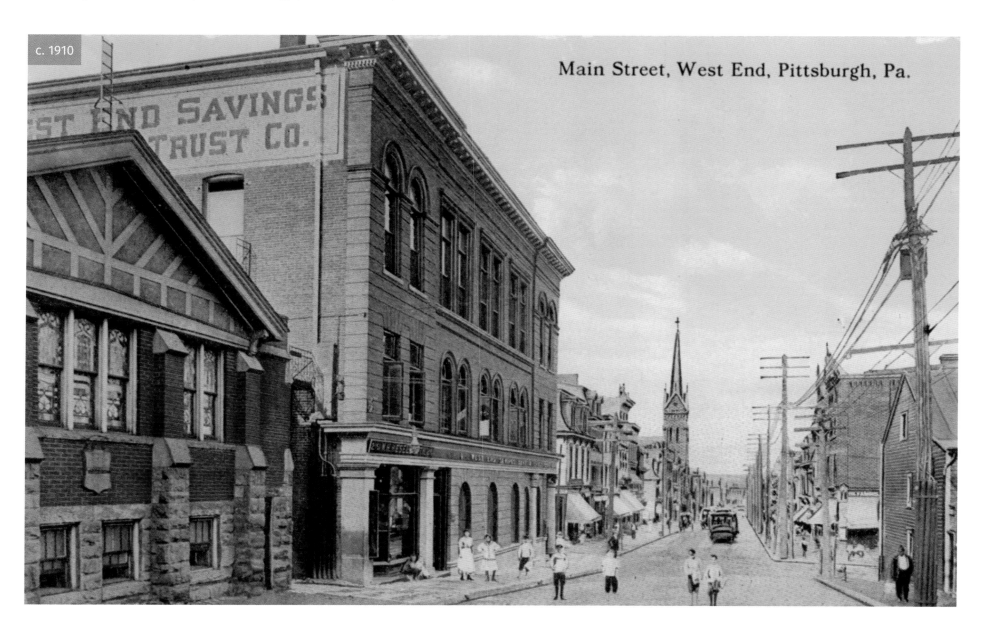

c. 1910

Main Street, West End, Pittsburgh, Pa.

LEFT: The West End of Pittsburgh runs inland from the Ohio River, with Saw Mill Run as its own little river between steep hillsides. The streets were laid out in 1839 as Temperance Village, and until annexation by Pittsburgh in 1872, alcohol was indeed forbidden. This view looks northerly on Main Street. The Eleventh United Presbyterian Church, on the left, is one of the most interesting buildings in this scene: its congregation seems to have given up on the ascending Gothic promise of its buttresses and settled for a half-timbered gable over the front element and a brooch spire on the stump of a tower (beyond view). The most prominent building is the Classical Revival West End Federal Savings & Trust Company of 1915. St. James Church of 1884 is in the distance.

BELOW: South Main Street is still the commercial heart of the West End community, but some noticeable changes have occurred. St. James Church has lost its Gothic spire, due to a gasworks explosion of 1927 across the Ohio River. The Presbyterian church has lost its original windows, and West End Federal now houses the Pittsburgh Firefighters' Federal Credit Union. The stone-fronted bank building of 1926 on the right-hand side of the street has been renovated for office and retail use. Business and community leaders value their historic main street that continues to attract new businesses, restaurants, and residents.

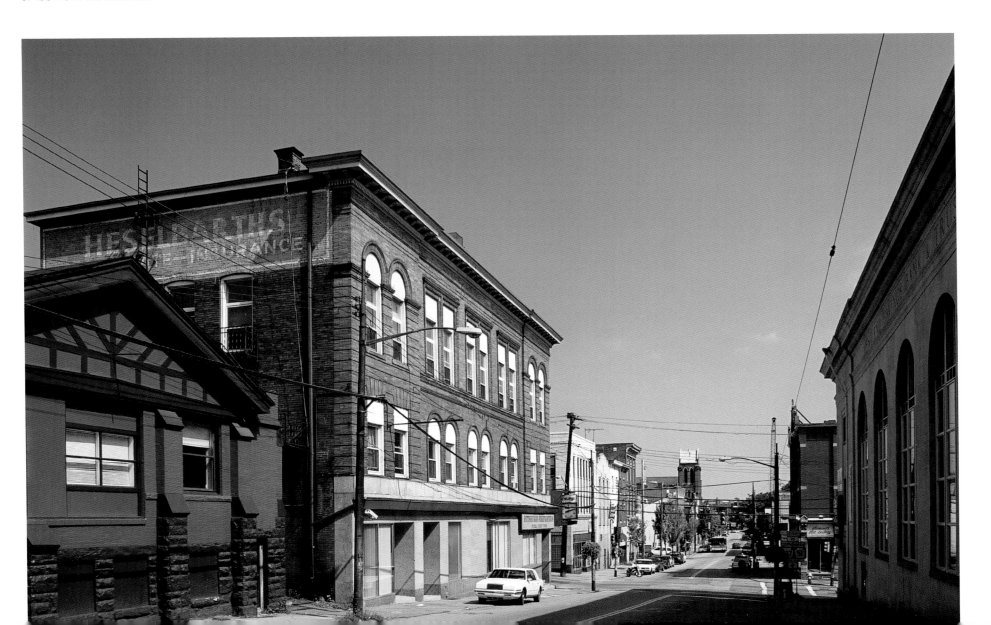

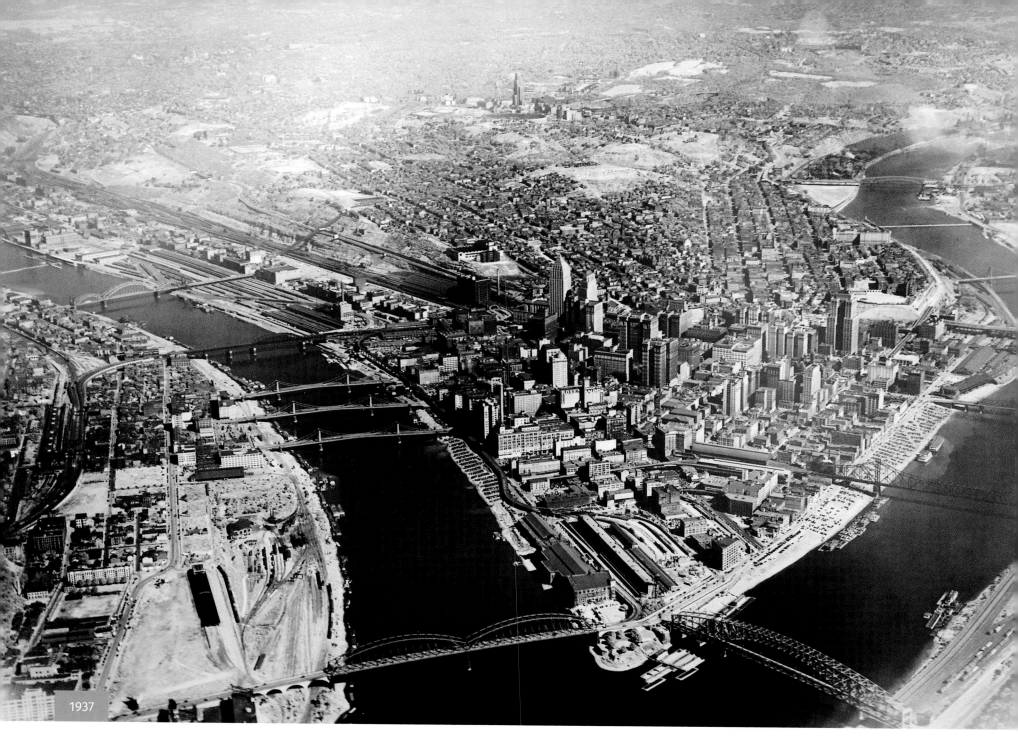

1937

THE GOLDEN TRIANGLE

Strategically located at the juncture of three rivers

142

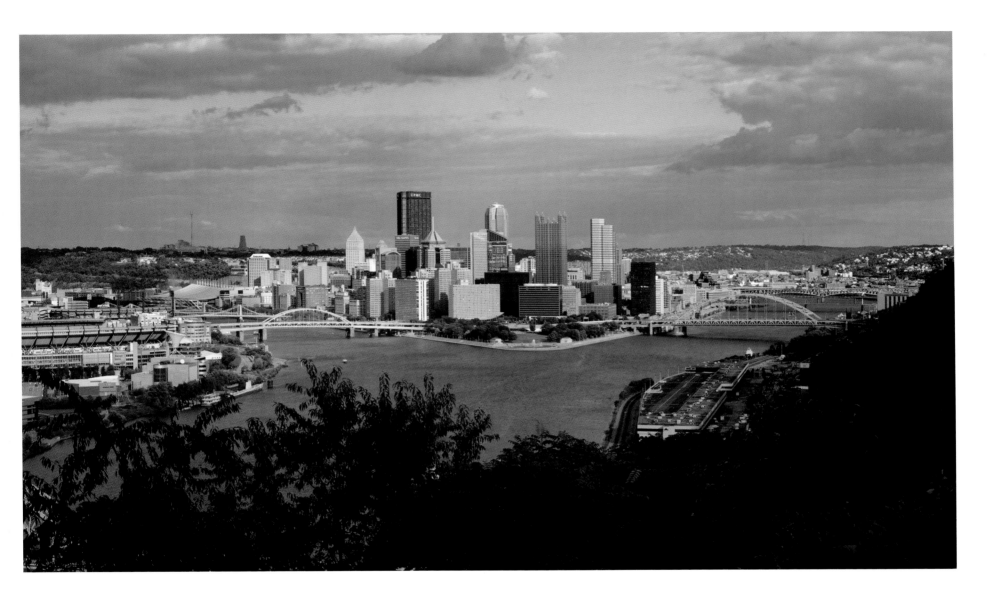

LEFT: Here is a final overview of the city, most likely taken in 1937 since the Cathedral of Learning, far away in Oakland, appears complete but the Monongahela Wharf is still a sloping parking lot. The Point still has its tied-up barges and trees between the bridge abutments, and further inland the railroad shares space, uneasily, with the Block House. The Three Sisters bridges on the Allegheny River are a decade old now, but the Wabash Bridge (second from bottom right) over the Monongahela River and the downtown terminal are still there. One can see trees and buildings far away, but this is still the Smoky City.

ABOVE: A comparable view today, from the West End Overlook 400 feet above the Ohio River, shows a city that has created its signature park and has more or less buried its old business architecture in newer and taller buildings, with the one built for U.S. Steel a signature of its own. The Carnegie Science Center and its submarine *Requin* are on the North Shore, and Heinz Field and PNC Park are beyond. Far away, as before, the Cathedral of Learning rises above the tree-covered hills and the little houses on their slopes. Nature is once again a surrounding, infiltrating presence in Pittsburgh, creating a beautiful, livable, and memorable city.

INDEX

OTHER TITLES IN THE SERIES

ISBN 9781910904053

ISBN 9781911595007

ISBN 9781911216452

ISBN 9781910904121

ISBN 9781911595946

ISBN 9781911216063

ISBN 9781910904800

ISBN 9781911216483

ISBN 9781911595571

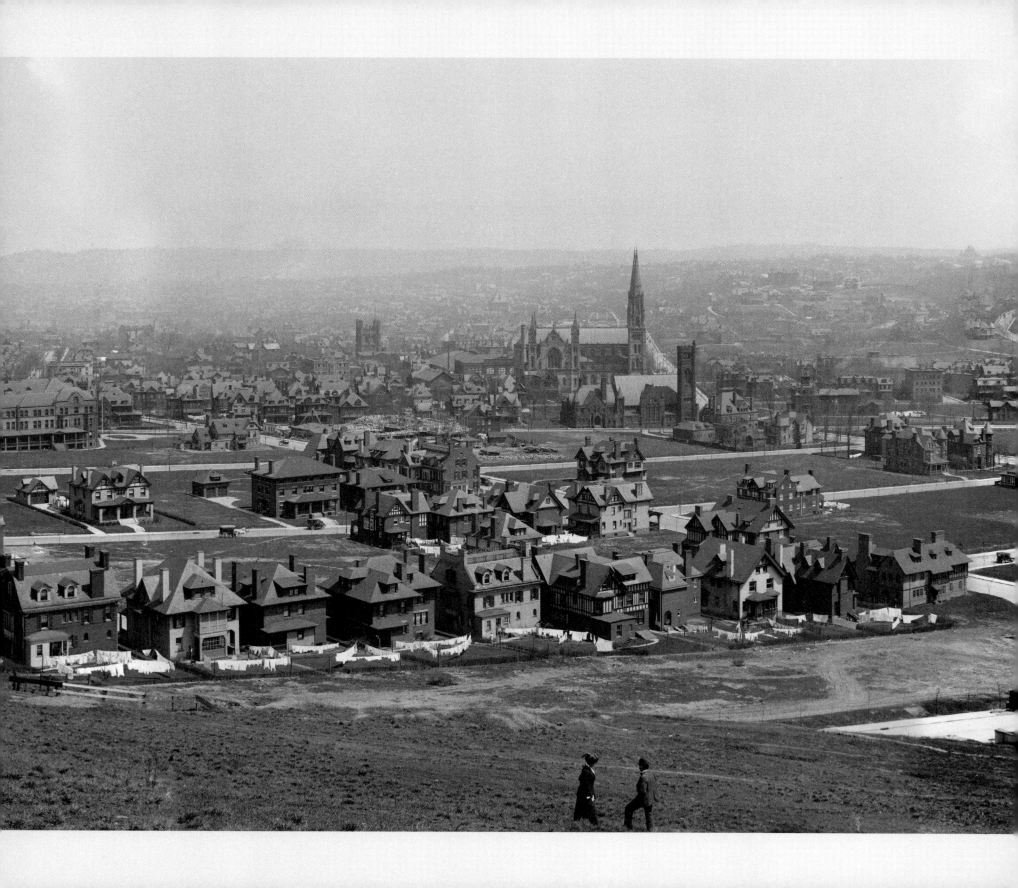